THE ART OF CREATIVE lettering

50 Amazing New Alphabets
You Can Make for
Scrapbooks, Cards, Invitations, and Signs

Becky Higgins

with Siobhán McGowan

Introduction by
Lisa Bearnson

CREATING KEEPSAKES BOOKS
Orem, Utah

Copyright © 1999 Becky Higgins. All rights reserved.
No part of this book may be reproduced or transmitted in
any manner whatsoever without written permission from
the publisher, except in the case of single-copy photocopies
made for use in personal craft projects.

Published in 1999 by Creating Keepsakes Books,
a division of Porch Swing Publishing, Inc.,
354 South Mountain Way Drive, Orem, Utah 84058,
(800) 815-3538. Visit us at www.creatingkeepsakes.com

Printed in U.S.A. on acid-free paper.

Library of Congress Cataloguing-in-Publication Data

Higgins, Becky.
 The art of creative lettering : 50 amazing fonts you can
make for scrapbooks, cards, invitations, and signs / by
Becky Higgins ; with Siobhán McGowan : introduction by
Lisa Bearnson.
 p. cm.
 Includes index.
 ISBN 1-929180-10-1 (alk. paper)
 ISBN 1-929180-11-x (pbk. : alk. paper)
 1. Lettering. I. McGowan, Siobhán. II. Title.
 NK3600.H49 1999
 745.6'1—dc21
 99-34049
 CIP

Creating Keepsakes Books
Washington, D.C. office
Book Program Director: Maureen Graney/Blackberry Press, Inc.
Art Director: Susi Oberhelman
Production Consultant: Kathy Rosenbloom
Editors: Erin Michaela Sweeney, Sonia Reece Myrick
Index: Pat Woodruff

Creating Keepsakes™ scrapbook magazine
Editorial Director: Lisa Bearnson
Creative Director: Don Lambson
Publisher and CEO: Mark Seastrand

Front cover photograph: Arnold Katz Photography, NYC.
Back cover photograph: Patrick Kerry, Provo, Utah.
Photograph on page 4: Arnold Katz Photography, NYC.

Creating Keepsakes Books may be purchased in bulk for sales
promotions, premiums, or fund-raisers. For information, please
write to: Special Markets Department, Creating Keepsakes
Books, 354 South Mountain Way Drive, Orem, Utah 84058.

02 03 04 05 9 8

Acknowledgements

I owe my sincerest thanks to so many people who influence my life for the better and who have made this book possible.

My deepest gratitude goes to Lisa Bearnson, editor and founder of *Creating Keepsakes* scrapbook magazine and one of my dearest friends, for inviting me to join the family at *Creating Keepsakes*. She has blessed me with many opportunities to express and share my enthusiasm for scrapbooking. I am also privileged to work alongside many talented friends in this company—they have been an inspiration to me.

Many thanks to Maureen Graney, president of Blackberry Press, for managing this book project and being patient with me. I appreciate her insight, capability, and enthusiasm. I wish to thank Susi Oberhelman for her incredible design expertise and for her ability to make everything flow together so well. To Siobhán McGowan, I am grateful for her amazing ability to take my thoughts and words and present them so eloquently. She is a gifted writer.

Several people deserve thanks for letting me use their photographs and create their scrapbook pages for this book as well as for other projects. I extend much appreciation to my friends, old and new, for their support and enthusiasm throughout this adventure.

My family means the world to me and I appreciate their love and encouragement. Heartfelt thanks to my five brothers and their wives for many years of fond memories and fun times. For cheering me on and offering moral support, I thank my parents, Wayne and Vicki Allgaier. They have always encouraged me to set goals and work hard to achieve them. Likewise, I thank my husband's family for being so kind—I am honored to call them my family.

Most of all, I wish to express my thanks to my best friend and husband, David. I am fortunate to have him by my side, holding my hand in life. I offer my gratitude to him for supporting my craziest of ideas and latest of nights. His sense of humor keeps me smiling and his encouragement keeps me going. It is a pleasure to share life with him.

Finally, thank you to scrapbookers everywhere. Your enthusiasm for the art of scrapbooking and your creative spirits keep this industry in full force. I admire your efforts to preserve memories and am thrilled to share excitement for this hobby with you. Keep up the great work!

—BECKY HIGGINS

CONTENTS

Introduction
by Lisa Bearnson **4**

Great Lettering Made Easy

In Praise of the Pencil **5** • Think Ink **5** • Making it Easy: The 6 Basic Structures **6**

Design Ideas for Scrapbook Pages **8** • Ideas for Headlines: Short and Sweet **10**

Design Ideas for Cards and Invitations **10** • Design Ideas for Signs and Posters **10**

Introduction

As the editor of a national scrapbook magazine, I'm exposed to many different scrapbooking styles. One of my favorites is that of scrapbooker Becky Higgins. I have yet to see a page done by her that I haven't loved. Why? Becky's pages are simple, not cluttered. The photographs always remain the stars, but Becky also creates her own lettering titles as the major accents on her pages. And her unique alphabets are tailored perfectly to a particular theme or feeling.

Now anyone can create "Becky Higgins" pages thanks to the easy-to-follow instructions and illustrations in this book. Not only will you learn fun lettering techniques, you'll also get a lot of great ideas for laying out scrapbook pages, writing catchy titles and using lettering

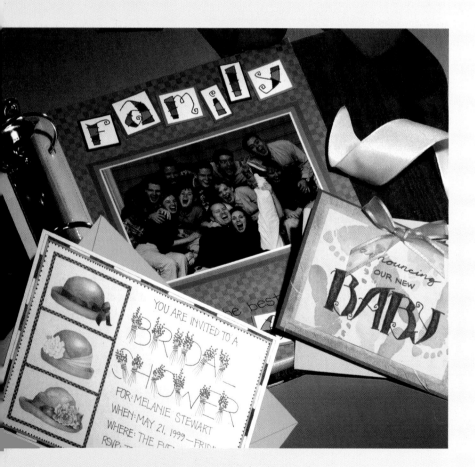

in other projects. Best of all, Becky lets you in on her own creative secrets so you can use the alphabets, patterns and ideas in this book over and over as springboards for your own scrapbook pages and paper projects. The uses for creative lettering are almost endless—in addition to scrapbook pages, you can make cards, invitations, signs, posters and labels. So, sharpen your pencil, get out the ink, turn on your imagination and enjoy the process!

Lisa Bearnson

Great Lettering Made Easy

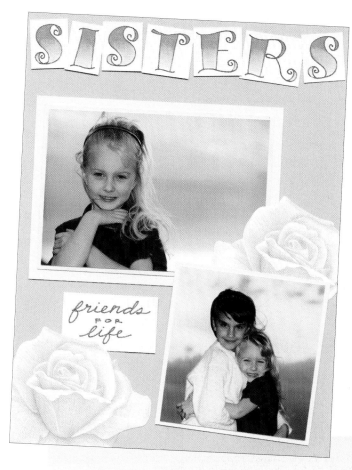

SISTERS **Black pen: Micron 05, Sakura. Pencils: Prismacolor, PC914 Cream and PC936 Slate Gray, Sanford. Roses: Wallies, McCall's.**

Anyone can learn lettering. All it takes is a little patience and a lot of pencils. There's an alphabet in this book with your name on it, something for every occasion—no exceptions. When you choose a lettering style and combine it with the right color or pattern, the results will revolutionize the way you look at your scrapbook—or your cards, posters, party invitations, and gift tags. The options and outlets for creative lettering are endless. Lettering can be used to tie a scrapbook page theme together, convey a message, or invoke a feeling. Funky fonts add a bold energy to your project, while Fancy fonts bring a touch of femininity. So grab your pencil, and get ready to write.

In Praise of the Pencil

Rarely has an instrument so effectively aided all who choose to use it. As dog is to man, so pencil is to project-maker: your best friend! As you embark on your creative lettering attempts, remember, there's a reason pencils have erasers. Allow yourself to make mistakes.

It's important to sketch your letters first, in order to figure out and fine-tune their individual shapes and internal patterns as well as to get the spacing right. By doing so, you'll save time and paper. When sketching letters in pencils, don't bear down too hard: Take it easy. Too much pressure will indent the page, making leftover lines hard to erase once you're ready to ink your title. Instead, keep lines faint. Take advantage of the "pencil stage" and revise to your heart's content. Get it perfect in pencil before you make it permanent with pen.

Think Ink

After penciled words and phrases are finalized, the next step is to outline them in ink. A fine-point pen in black is the most basic way to give your titles weight and definition, although exceptions are noted throughout the book. For example, while Swirls (p. 36) deserves a fine-point pen to express its elegance and delicacy, Chunky Block (p. 18) sometimes demands a thicker treatment. Space can be a consideration: Limited room means thinner lines. But when drafting large signs and posters, a thick point is non-debatable. As for colored outlines, they tend to weaken lettering. Don't be afraid to experiment with different shades, but do so sparingly. When in doubt, black is best.

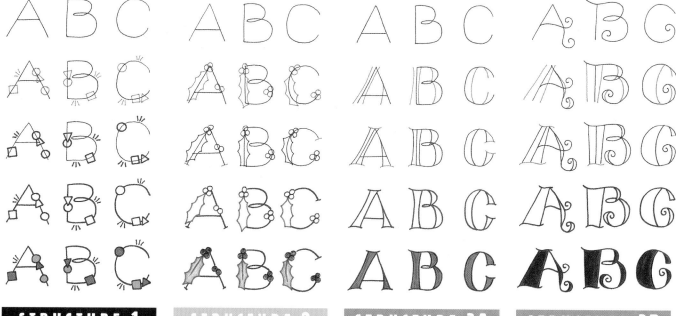

| STRUCTURE 1 | STRUCTURE 2 | STRUCTURE 3A | STRUCTURE 3B |

Making It Easy: The 6 Basic Structures

Now that your pencil's in hand, here's the best news. There are just six basic structures underlying the alphabets in this book. Once you've mastered one structure, you've mastered all the related alphabets!

The structures can be broken down into a few easy steps illustrated here. Write-ups that accompany each alphabet later in the book give lots more ideas, hints, and tips for making and using these inventive lettering styles.

Two alphabets, Sunshine (p. 90) and Logs (p. 110) simply place Basic Lettering in decorative boxes and don't need any special instructions. Arrows (p. 63) and Strips (p. 78) are unique— just copy the sample alphabets.

STRUCTURE 1: Print

1. Pencil your letters.
2. Add ornaments in pencil: geometric shapes for Geometric, shown here, open circles for Circle Serif, smiley faces for Happy Kids, circles and rectangles for Southwest, and bits of fabric for Quilt Squares.
3. Ink in the ornaments first.
4. Ink in the letter lines. After the ink dries, erase leftover pencil markings.
5. Color in!

STRUCTURE 2: Shapes & Motifs

1. Pencil your letters.
2. Draw shapes or motifs over the main vertical lines of the letters as in Holly & Berries, shown here. If you're using stickers or punched shapes, decide where they will go but don't stick them down yet.
3. Add serifs and ornaments in pencil, checking the connection between the letter lines and the shapes or motifs.
4. Ink in ornaments first and letter lines second if you're drawing the shapes and motifs. If you're using stickers or punches, ink in the letter lines first, then affix the decorations. After the ink dries, erase leftover pencil markings.
5. Color in!

STRUCTURES 3A & 3B: Fill-In

1. Pencil your letters. Some Fill-In fonts start out with slightly altered letter shapes.
2. Thicken spaces on both sides of the main vertical line as in Classic, 3A. In many cases, you'll also thicken the smaller spaces opposite the main vertical, usually by adding a line on the inside, as in Voluptuous, 3B.
3. Add serifs. Many extend slightly beyond the edge of the letter shape.
4. Ink in. After the ink dries, erase leftover pencil markings.
5. Color in!

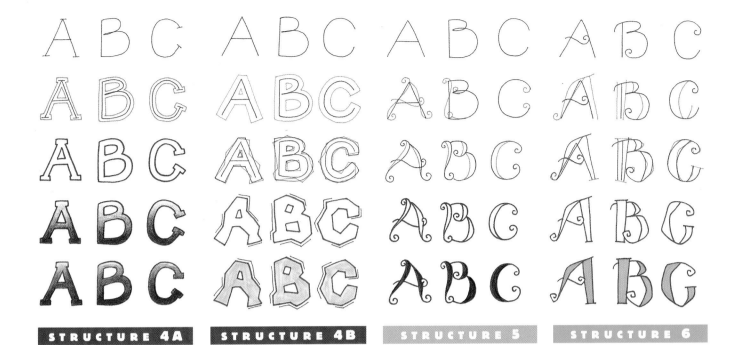

| STRUCTURE 4A | STRUCTURE 4B | STRUCTURE 5 | STRUCTURE 6 |

STRUCTURE 4A: **Block**

1. Pencil your letters.
2. Thicken spaces around all sides of each letter, adjusting and erasing until you have parallel lines and even spaces all around. Also add the alphabet's special embellishments at this stage: square serifs, tilts, notches, twigs, or outline boxes.
3. Ink in. After the ink dries, erase leftover pencil markings.
4. Color in! This Skinny Serif sample shows the first half of a special two-tone pencil effect, blending, in which the darker hue is applied with increasingly lighter pencil shadings.
5. This sample shows the second stage of blending, using the lighter pencil color.

STRUCTURE 4B: **Special Treatment for Choppy and Spiky Block**

1. Pencil your letters.
2. Thicken spaces around all sides of each letter, adjusting and erasing until you have parallel lines and even spaces all around.
3. Jut in and out of each line with crooked lines, cutting off corners for Choppy Block, shown, or, for Spiky Block, taking little bites. The underlying basic letter will help keep you from distorting the letter too much.
4. Ink in and add shake marks for Choppy Block, shown, or spiky accents for Spiky Block. After the ink dries, erase leftover pencil markings.
5. Color in!

STRUCTURE 5: Curly

1. Pencil your letters.
2. Get rid of those straight lines! Go over every line in the penciled letters, making each one wavy and curly.
3. As appropriate, apply special techniques from other alphabet structures. In the Swirls alphabet, shown here, use the thickening technique from the Fill-In Structure to create an elegant effect. Two Curly alphabets—Tulips and Pumpkin Patch—add little drawings at this stage as the Shapes & Motifs types do.
4. Ink in. After the ink dries, erase leftover pencil markings.
5. Color in!

STRUCTURE 6: Angular

1. Pencil your letters. Notice that most angular letters, such as Flair, shown here, start out with a rounded or angular swirl.
2. Thicken spaces around the main vertical line of the letter, or, in the case of Zigzag, on the inside. Curl parts of the letters as needed.
3. Add angles and serifs. Extend lines beyond the edges of the thickened letters if needed. Add other ornaments: hatch marks for Stitches, shadowing lines for Fiesta, circle accents for Sports Balls. Adjust lettering.
4. Ink in. After the ink dries, erase leftover pencil markings.
5. Color in!

Design Ideas for Scrapbook Pages

The many varieties of lettering in *The Art of Creative Lettering* can be compared to the number of ice cream flavors available today: Once you've tasted a few, it's tempting to overindulge. Resist the urge! Creative lettering is most effective when it has a little breathing room. This less-is-more mentality applies to both words within a title and the overall design of your scrapbook page.

Highlight key words in your title with creative lettering, and leave the rest alone. In longer phrases, the effect of the title is stronger when you limit the lettering to one, two, or three words. Write smaller, connecting words in everyday handwriting. This saves time and space. For example, in the title "Out with the Old, In with the New" (p. 35), "Old" and "New" are the two words that will most benefit from creative lettering.

Once in a while, it's fun to create a title out of letters from all different alphabets, but that can quickly tire the eyes. Don't mix and match too much. Stick to a single style.

By the same token, don't feel obliged to draw a masterpiece daily. Just the thought of trying to creatively letter a title on every scrapbook page takes all the joy out of it. Reserve creative lettering for special events or topics. By placement, framing, or mounting on different papers, you can make plain print or everyday handwriting stand out. Often, this can have as strong an effect as a creative alphabet.

Finally, when thinking through the layout of your page, keep the lettering block in mind from the very beginning. A strong title can anchor a page; photos, along with any journaling, can be adjusted around it. Headlines are as important a component as images, especially on title pages that announce a new subject: Subsequent pages in the same series may not need creative lettering at all. Sometimes, accidentally, people compose their page of photos, only to realize too late that there's no room for a headline. There's something uncomfortable about a page that cramps its title into leftover space. The solution: plan ahead!

Title Placement

Headings centered at the top of the page convey a neat look, like the first page of a proudly presented school report. But you miss half the fun if you do that all the time, especially considering the other placement options. Shake off your memories of homework assignments, and graduate to:

- **Word Boxes:** Place each word of a title in its own box, and vary their shapes and sizes. Try ripping the edges of your boxes (see p. 16, "Strawberry Baby"; p.36, "A Comfortable Bride . . ."; p. 43, "Annual Cousins Christmas Party"; p. 66, "Friends are the Spice of Life").

- **Letter Boxes:** Place each letter in its own box. Line them up straight or tip them head to toe. Run them down the side of the page or even in a rainbow arch (see p. 58, "Grandparents,"; p. 87, "Alpine Ski Resort";

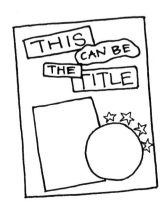

p. 70, "Discovery Zone"; p. 77, "Kaulin's Last Day of School"). Vary the shape and size of each box in a word or title (see p. 52, "Like Father, Like Son"; p. 56, "Family...Friends"; p. 56, "Lemonade").

- **Strips:** Using a color different from the background, mount your title on a strip of paper, and run it across the top or bottom of the page on the diagonal (see p. 40, "Prom 1997"; p. 25, "Friends"; p. 115, "Blast Off"). Not only does this enhance the headline, it's helpful if you make a mistake-the whole spread isn't affected, just the strip, which is easily replaced.

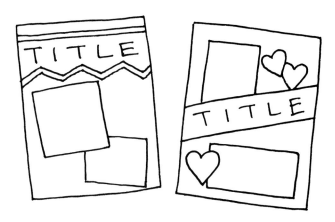

- **Silhouettes:** After drawing each letter on paper, cut around the individual letters, silhouetting close to the pen lines (see p. 50, "Picnic"; p. 119, "Crabcakes").

- **Photo Mats:** When you mat a photo onto cardstock, you trim all four sides of the paper close (about 1/8 of an inch) to the edges of the photo. If you leave one side wider than the others, you can use this room for your lettering! See "Before and After," p. 20.

- **String**: Hang your individual letters or your title block like a picture, using actual rope or string, or illustrate the same idea using thin pen lines (see p. 48, "Bonfire"; p. 52, "Jeep Safari"; p. 74,"Halloween 1978").

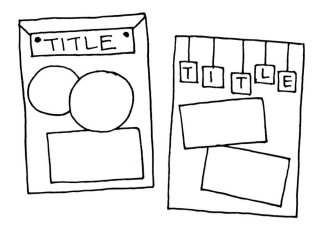

- **Space Sharing:** Include your title on the same block as your subtitle or your journaling. Outline the title first, but color it in after you write the journaling or subtitle. (Leave enough room so that if you make a mistake on one part, you can trim it away and adjust your layout.) For samples see p. 58, "Happiness"; p. 63, "Travel & Tourism"; p. 94, "Olivia's First Christmas"; p. 87, "Sledding"; p. 114 "Field Trip."

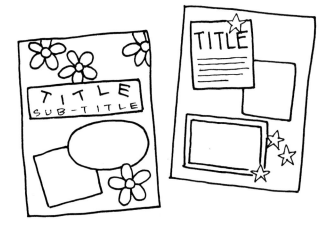

However you position your titles, aim for legibility. A title that runs vertically down the page is not as readable as a traditional horizontal line: Try it now and then (see p. 54, "Camping"; p. 20,"What a Mess!"), but not too often.

Size Matters

Proportion is paramount. Gather all the elements of your page in front of you, then decide how prominent the title should be: For a standout headline or a title page preceding a series, go as large as you can without tipping the balance among the photos and memorabilia.

Style and Substance

Lettering sets the mood for a spread. For example, unless your wedding ceremony was an atypical affair, the elegant Swirls (p. 36) is a better bet than Chunky Block (p.18). Other occasions are open to interpretation. The obvious choice for a birthday party invitation might appear to be Balloons (p. 106), but don't forget Zigzag (p. 72). Or Southwest (p. 52), if a piñata will be part of the festivities.

Color

All the elements on a page should complement, not combat, one another. You might think first

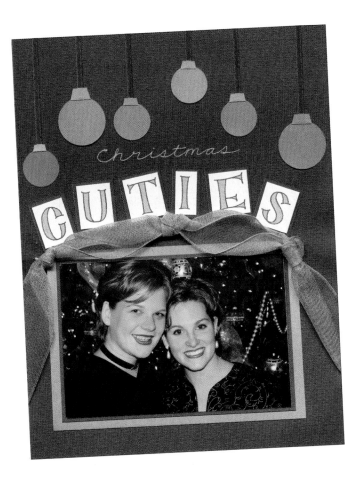

of orange for a Halloween scrapbook page, but if your daughter was a ballerina, try pink instead. On the other hand, an "Over-the-Hill" birthday party will lose its gallows humor if the invitation is spelled out in cheery brights.

Ideas for Headlines: Short and Sweet

Shorter headlines stand out. A few well-placed words pack a punch. Literally, the less said (or lettered), the better. Why ramble on with "Our Trip in June 1997 to Disneyland in Anaheim, California" when "Disneyland" sums it up succinctly? Journaling elsewhere on a scrapbook page can tell the rest of the story. In a series of pages, the title spread might state the general subject—"The 1999 Family Reunion"—so that subsequent pages can focus on the specifics: "Hanging Out with Our Cousins" and "The Bake-Off," for example.

Design Ideas for Cards and Invitations

To the rescue, here comes the indispensable, incredibly handy, highlighting technique: Because space is at a premium on cards, including invitations and announcements, highlighting is the best way to emphasize key words without overwhelming the text. Of course, if you make your own card, it can be as big as you please, as long as you craft a matching envelope to house it! Although you can stand your cards horizontally or vertically, the advantage of the former, with the fold at the top, is the wide writing space. Short titles, such as "Get Well Soon" on p. 68, sit comfortably on vertical cards.

Design Ideas for Signs and Posters

Posters are the place to pull out all the stops when it comes to creative lettering—the whole point of a poster is to grab the attention and hold the interest of your audience. Choose a relatively basic alphabet, then make it BIG, so that people will be drawn to it from a distance. Readability is crucial, whether your sign is an advertisement (free puppies, apartment for rent, garage sale, lost

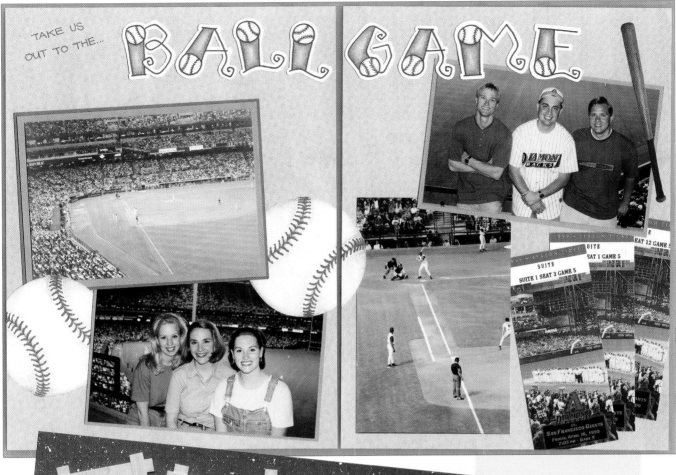

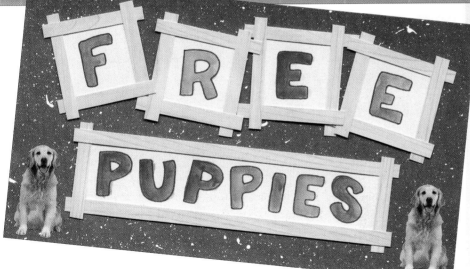

TAKE US OUT TO THE... BALL GAME

FREE PUPPIES

CHRISTMAS CUTIES
Black pen: Micron 05, Sakura. Gold pen: Gelly Roll, Sakura. Circle punch: Family Treasures. Ribbon: Offray.

BALL GAME Red pen: Marvy Le Plume, English Red No. 28. Black pen: Micron 02 and 08, Sakura. Pencils: Prismacolor, PC911 Olive Green, PC945 Sienna Brown, Sanford. Pencil blender: Prismacolor, Sanford. Paper: Boyd's Bears, InterArt Distribution. Baseballs: Wallies, McCall's. Bat sticker: Frances Meyer.

FREE PUPPIES Brown pen: ZIG Writer (Chocolate), EK Success. Watercolor: Staedtler (Dark Ochre). Stickers: Paper House Productions. Paper: Bazzill Engraving Co.

cat, bake sale, car wash) or announces an event (a party, PTA meeting, church activity, book club). Highlight one, two, or three key words—if you write out all the specifics in a creative font, it will be too much work to read—and place them at or near the top of the sign. Or, if space permits, try positioning the main headline toward the center, and lead up to it with a few smaller, highlighted words (see p. 92, "Fireworks").

BASIC alphabets

Trends may come and trends may go, but the basics are always in style. This is a group of letters you can always rely on. The seven alphabets classified as Basic—from the simple Circle Serif to the solid Chunky Block—are clean and clear. They can't be bothered with adornments and detail— they're here to get the job done. Some Basic alphabets require a small amount of special attention, others are easily perfected, but all work on any kind of card or page. Pick a Basic alphabet for your project, then use color and pattern to match the theme, enhance the mood, and individualize the letters.

Basic Lettering

Think back to your elementary school days, when you first learned your ABCs, and when the fundamentals of clean penmanship counted. That's the idea behind Basic Lettering. To get you back to basics—and back in the habit of writing clearly.

Basic lettering is at the heart of every lettering structure, no matter how much you embellish, thicken, curl, angle, or otherwise redraw your letters. In titles, clean plain lettering is a great companion to the masterpieces of creative lettering you will read about in this book. And you can use Basic lettering for journaling, too!

So try to bring to mind the sage words and sound advice of good old Miss First Grade Teacher, and practice, practice, practice your lettering. Any questions, class?

UPPERCASE

LOWERCASE

CURSIVE

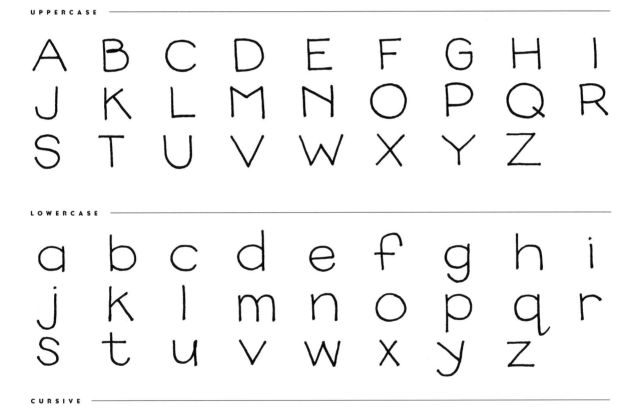

Classic

The Classic alphabet, formal but versatile, brings elegance to any occasion. No other font has as many uses.

Write out the word in pencil, allowing enough room between letters to add thicker spaces (see pp. 6 and 7). Longer, vertical sections are obvious locations for thick blocks of color, but color can also be added to the triangular ends of letters—the crossbar of the "T," for example. When making thick spaces, flair your lines slightly. Then mirror this bell-bottom effect with concave serifs that extend just beyond the letters' edges. These touches give Classic its personality.

Black is best for outlining, but Classic can carry other colors. Outline with a darker color then fill in with lighter shades. To intensify the look, concentrate the color toward the top of the letter and let it fade out toward the bottom.

DOUBLE RECEPTION Black outline: Micron 03, Sakura. Pencil: Prismacolor, PC 1026 Greyed Lavender, Sanford. Leaf accents: Distinctions in Nature, Wangs Intl.

HIGGINS FAMILY Black pen: Micron 01, Sakura. Brown pen: ZIG Writer (Coffee), EK Success. Corners: 3L. Leaf punches: Family Treasures.

HAPPY ANNIVERSARY Black outline: Marvy Le Plume, No. 18 Dark Brown. Pencil: Prismacolor, PC 1017 Clay Rose, Sanford. Daisy punch: Family Treasures. Circle punch: McGill. Paper: The Robins Nest.

ALPHABET • FILL-IN STRUCTURE Black outline: ZIG Writer, EK Success. Pencil: Prismacolor, PC 1005 Limepeel, Sanford.

Aa Bb Cc Dd
Ee Ff Gg Hh
Ii Jj Kk Ll
Mm Nn Oo Pp
Qq Rr Ss Tt
Uu Vv Ww
Xx Yy Zz 1 2
3 4 5 6 7 8 9

Crooked Classic

Think of Crooked Classic as an alphabet that's overflowing with energy. The lines waver just a little, and the curved serifs wind up in spirited swirls. This versatile font can be quite elegant, yet it lends itself to outdoorsy, organic topics: camping in the woods, gardening in the yard—maybe even plucking a plump, juicy baby from the strawberry patch!

The best way to begin a Block Structure alphabet is to sketch a skeleton letter in pencil, then outline this frame to make the thicker form. Instead of capping the ends of each letter with a traditional flat top, gently curve the serifs. Don't be afraid to rearrange the placement or number of serifs depending on the word or title—let your eye be your guide. On the "Strawberry Baby" page, extra swirls spruced up two of the "r's."

When tracing over the pencil marks in pen, start with the swirly serifs to anticipate any spacing problems. Keep the serifs smooth, but, for the rest of the letter, shake your hand slightly, so that the lines end up crooked. As for coloring, the "Thinking of you" example shows that watercolors work particularly well with Crooked Classic.

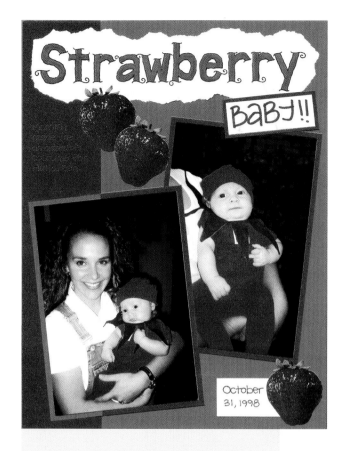

STRAWBERRY BABY Black outline: ZIG Writer, EK Success. Red pen: ZIG Scroll & Brush, EK Success. Strawberry stickers: Paper House Productions.

THINKING OF YOU Black outline: Pigment Liner 03, Staedtler. Watercolor: Staedtler (Violet). Fun tip: Each letter has a different amount of water added to the brush.

LYDIA SUZANNE Black outline: ZIG Millennium 05, EK Success. Pencil: Prismacolor, PC944 Terra Cotta, Sanford. Blender: Prismacolor, Sanford. "Suzanne": ZIG Writers (script is Wheat and capitals are Coffee), EK Success.

ALPHABET • BLOCK STRUCTURE Black outline: ZIG Writer, EK Success. Pencils: Prismacolor, PC932 Violet and PC956 Lilac, Sanford.

Aa Bb Cc Dd
Ee Ff Gg Hh
Ii Jj Kk Ll
Mm Nn Oo Pp
Qq Rr Ss Tt
Uu Vv Ww
Xx Yy Zz 1 2
3 4 5 6 7 8 9

Chunky Block

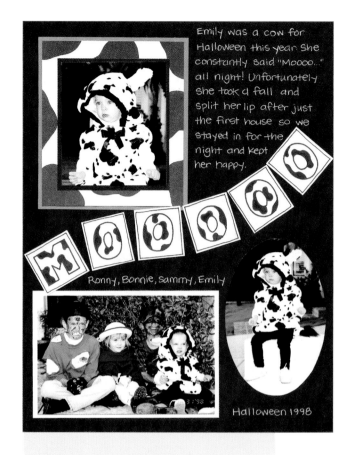

Emily was a cow for Halloween this year. She constantly said "Moooo..." all night! Unfortunately she took a fall and split her lip after just the first house so we stayed in for the night and kept her happy.

Ronny, Bonnie, Sammy, Emily

Halloween 1998

hunky Block's "snuggles and slants" are its special features. The slant comes from the way each letter tilts forward and backward on its heels. When one letter overlaps another a little bit—that's the snuggle!

To get the Chunky Block look, think thick. Write the letters in pencil, alternating the direction of the slant. Next, outline the letters by drawing parallel to and an equal distance (on both sides) from the original line. Make any needed adjustments and decide which letter in the overlaps will be on top. With a pen, outline the letters—only the "top" letter in an overlap. Erase pencil markings, then color in the empty spaces with pencils, chalks, or brush-tip pens. Patterns work especially well in this font.

MOOOOO Black pens: Micron 03 and 08, Sakura. White pen: Milky Gel Roller, Pentel. Cow print paper: Provo Craft.

ARIZONA Black outline: Micron 08, Sakura. Red pen: Marvy Artist, No. 2 Red. Yellow pen: Marvy Le Plume, No. 43 Brilliant Yellow.

DALLAS Black outline: Marvy Artist. Skyline: ZIG Millennium (03), EK Success. Blue pencil: Memory Pencils, EK Success. Yellow pen: Marvy Artist, No. 5 Yellow.

ALPHABET • BLOCK STRUCTURE Black outline: ZIG Writer, EK Success. Pencils: Prismacolor, PC903 True Blue, PC956 Lilac, PC992 Light Aqua, PC993 Hot Pink, Sanford.

Aa Bb Cc Dd Ee
Ff Gg Hh Ii Jj
Kk Ll Mm Nn Oo
Pp Qq Rr Ss Tt
Uu Vv Ww Xx Yy
Zz 1 2 3 4 5
6 7 8 9 0

Skinny Serif

Throw a cuffed turtleneck sweater on to each letter of Skinny Serif and it's ready for any occasion—formal, festive, plain ol' everyday. Thin block letters finished with narrow rectangular collars and cuffs, Skinny Serif is a solid, basic font instantly individualized by color.

In pencil, write out a skeleton form of each letter in the word or phrase, then draw parallel lines on both sides of the original to form a block letter (see pp. 6 and 7). Draw the parallel lines close to the original for a thin block—this is Skinny Serif, after all. To create the serifs, simply attach a small rectangle to the ends of the outlined letters.

The trick with this alphabet is to keep the thickness of the blocks consistent. Lines should be straight, but don't worry about using a ruler—your eye is the best judge. Go over your letters, erasing and adjusting until they are all uniform in appearance. Stretching the letters tall will make for a more formal feel.

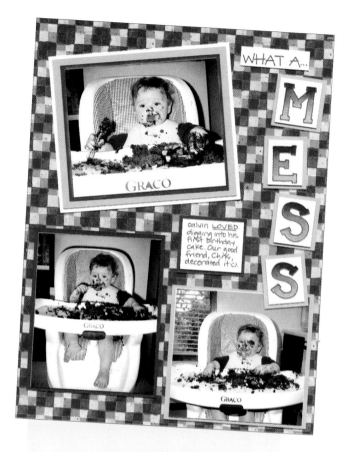

WHAT A MESS Black pens: Micron 01 and 05, Sakura. Pencils: Prismacolor, PC901 Indigo Blue and PC904 Light Cerulean Blue, Sanford. Paper: Keeping Memories Alive.

BEFORE & AFTER Black pen: ZIG Writer, EK Success. Red pencil: Prismacolor, PC924 Crimson Red, Sanford. Plaid papers: Keeping Memories Alive and Northern Spy. Dotted paper: Paper Patch. Daisy punch: Family Treasures. Flower punch: McGill. Fun tip: The tiny strips on the gift are cut with a paper trimmer and curled on their own.

BRUNSWICK HIGH SCHOOL Black outline: Micron 05, Sakura. Black cursive: Micron 08, Sakura. Pen: Marvy Le Plume, No. 82 Mustard and No. 28 English Red.

ALPHABET • BLOCK STRUCTURE Black outline: ZIG Millennium 03, EK Success. Blue pencil: Memory Pencils, EK Success.

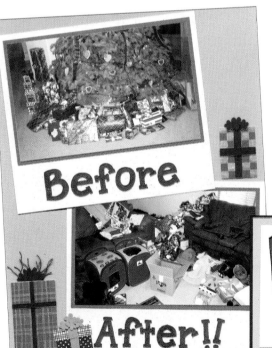

Aa Bb Cc Dd
Ee Ff Gg Hh
Ii Jj Kk Ll
Mm Nn Oo Pp
Qq Rr Ss Tt
Uu Vv Ww
Xx Yy Zz 1 2
3 4 5 6 7 8 9

Circle Serif

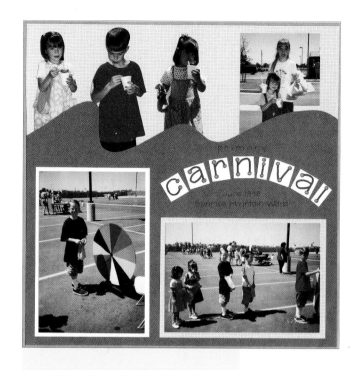

Tiny dewdrops drip from the ends of Circle Serif letters. As easy as pie, this alphabet still allows you to tie color into your lettering—the circles provide the perfect place to add just a jot. For bigger bursts of color, blow out the bubbles like you're blowing bubble gum. And why stop at circles? With a simple sleight of hand, these letters can be converted into square, spiral, or triangle serifs.

Before beginning to pencil out the word or phrase, quickly review the sample alphabet: On most letters, the circle serifs are placed right at the ends, but wherever two lines meet—at the top of "A," for example, or the bottom of "W"—the circle acts like an elbow joint, connecting one line to the other at the point where the two would have met. Leave a little room for these elbow joints when you first draw the letters. Use a thin pen for the circle serifs, then a thick pen for lettering. Touch up the spots where the thicker lines connect with the circles using the thin pen. As demonstrated in "Happy Birthday Janessa," the letter lines can be thin, too.

For a playful look, mix and match upper- and lowercase letters, or outline each letter in either black or a complementary color—just be sure to leave a little extra room in advance.

CARNIVAL Black outline: ZIG Writer, EK Success. Blue pen: ZIG Writer (Splash), EK Success. Yellow plaid paper: MPRs Paperbilities III.

HAPPY BIRTHDAY JANESSA Black outline: Micron 08 and 005, Sakura. Pink pen: ZIG Writer, EK Success. Checked paper: Paper Adventures.

SPENCER MADSEN Black outline: Marvy Artist. Colored Swirls: Marvy Le Plume, No. 2 Red, No. 11 Light Green, No. 75 Sky Blue, and No. 43 Brilliant Yellow. Stickers: Me & My Big Ideas.

ALPHABET • PRINT STRUCTURE Thick black pen: Marvy Artist. Thin black and red pens: ZIG Writer, EK Success.

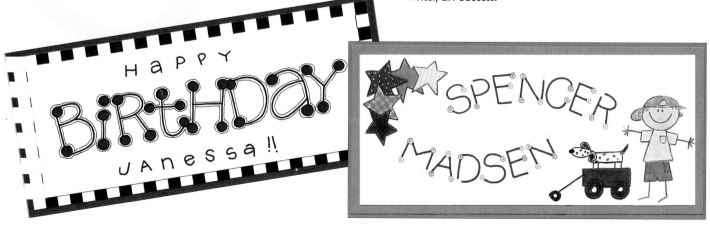

Aa Bb Cc Dd
Ee Ff Gg Hh
Ii Jj Kk Ll
Mm Nn Oo Pp
Qq Rr Ss Tt
Uu Vv Ww
Xx Yy Zz 12
3 4 5 6 7 8 9

Stacks

Pack 'em up and pile 'em high! A wobbly column of bricks supports every letter of Stacks, and each can hold its own color.

Start by penciling the letters, then draw a second line along the side of each one. For circular letters, this line will run along the inside of the curve. Within this space, sketch thin rectangular boxes, keeping them slightly askew and stacked head to toe. Think the bricks are too tiny? Fatten them up into squares.

After erasing pencil marks, outline the blocks with a fine-point pen. Black works best, but colored ink is an option.

STACKS ———————————————————

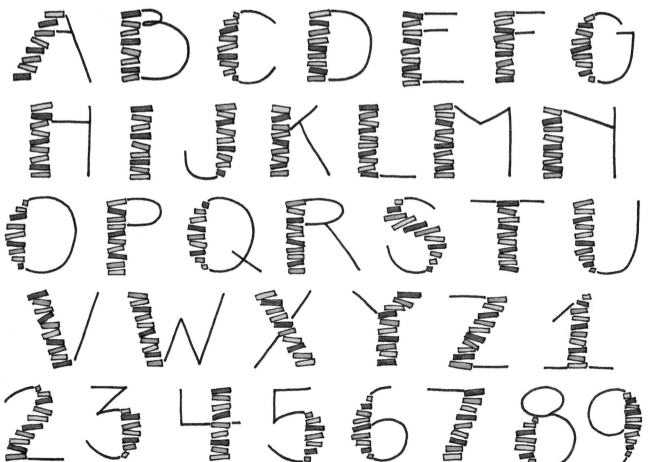

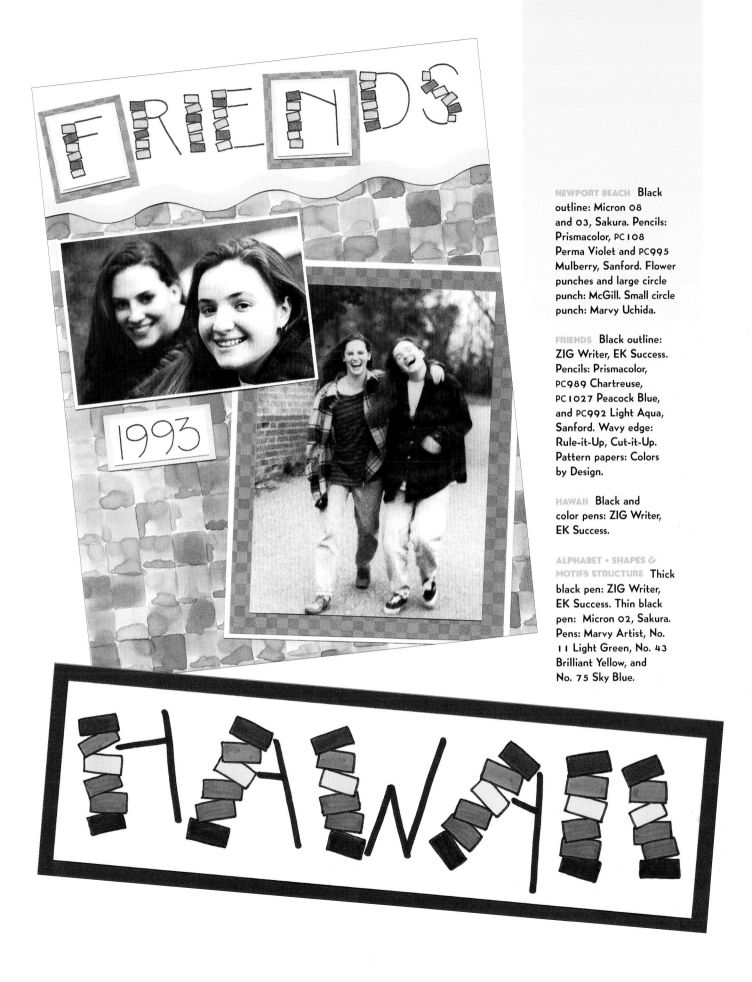

NEWPORT BEACH Black outline: Micron 08 and 03, Sakura. Pencils: Prismacolor, PC108 Perma Violet and PC995 Mulberry, Sanford. Flower punches and large circle punch: McGill. Small circle punch: Marvy Uchida.

FRIENDS Black outline: ZIG Writer, EK Success. Pencils: Prismacolor, PC989 Chartreuse, PC1027 Peacock Blue, and PC992 Light Aqua, Sanford. Wavy edge: Rule-it-Up, Cut-it-Up. Pattern papers: Colors by Design.

HAWAII Black and color pens: ZIG Writer, EK Success.

ALPHABET • SHAPES & MOTIFS STRUCTURE Thick black pen: ZIG Writer, EK Success. Thin black pen: Micron 02, Sakura. Pens: Marvy Artist, No. 11 Light Green, No. 43 Brilliant Yellow, and No. 75 Sky Blue.

FANCY alphabets

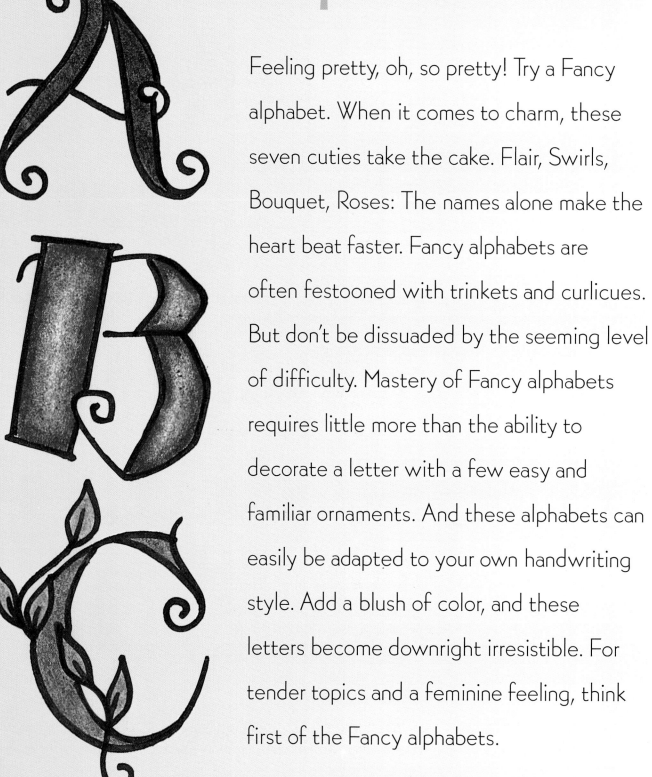

Feeling pretty, oh, so pretty! Try a Fancy alphabet. When it comes to charm, these seven cuties take the cake. Flair, Swirls, Bouquet, Roses: The names alone make the heart beat faster. Fancy alphabets are often festooned with trinkets and curlicues. But don't be dissuaded by the seeming level of difficulty. Mastery of Fancy alphabets requires little more than the ability to decorate a letter with a few easy and familiar ornaments. And these alphabets can easily be adapted to your own handwriting style. Add a blush of color, and these letters become downright irresistible. For tender topics and a feminine feeling, think first of the Fancy alphabets.

Roses

Everything's coming up Roses in an alphabet whose every letter blooms with dainty buds. Use this delicate font for your most precious pictures—the results are darling.

Pencil the curled lines and wide, open, low-waisted letters of your word or phrase using the sample alphabet for reference. Note how the curled ends of lines come close to, but don't touch, the rest of the letter—at the top of "A," for example, or the nostril of "P." Each uppercase letter holds three roses, while most lowercase letters have only one. To draw each rose, sketch a loose oval, starting at the top and curling the end of the line underneath to create a small swirl that resembles the tight, closed petals of a bud. If space permits, increase the size of the blossoms for a truly lush look ("Warmest Wedding Wishes"). And cluster the blossoms together, as if they were in a nosegay. On either side of the roses, add a small, almond-shaped leaf at a jaunty angle. Erase any pencil lines running underneath the flowers.

When outlining the letters, begin with the roses and leaves. Use a dark-colored ink, then shade the flowers with a lighter hue of the same shade. Chalks or pencils keep the look soft, although ink can convey softness, too. Trace the rest of the letter with a fine-point pen that's the same color as the one used (or black) to outline the flowers.

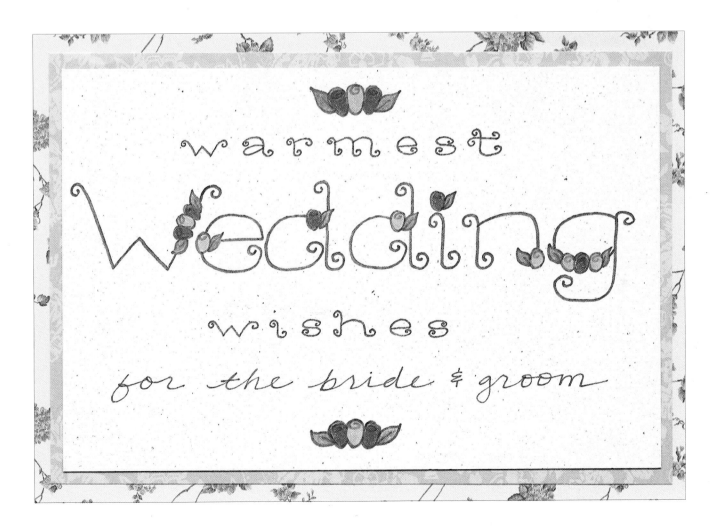

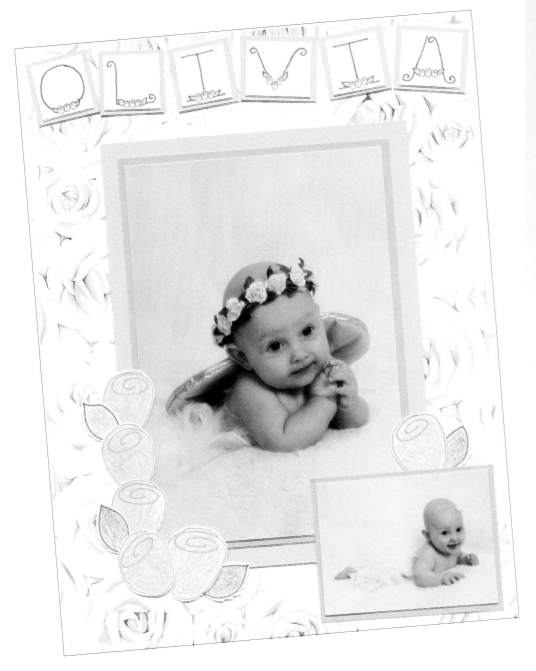

WARMEST WEDDING WISHES Black pen: ZIG Millennium 03 and 05. Pencils: Prismacolor, PC988 Marine Green, PC1017 Clay Rose, and PC1029 Mahogany Red, Sanford. Paper: MiniGraphics.

OLIVIA Pens: ZIG Writers (Evergreen and Wheat), EK Success. Pencils: Prismacolor, PC911 Olive Green and PC942 Yellow Ochre, Sanford. Paper: Colors by Design. Leaf punch: Family Treasures.

OUR ANNIVERSARY DINNER Black outline: Micron 02, Sakura. Red and green pens: Marvy Medallion 05. Decorative corners: K & Co.

ALPHABET • CURLY STRUCTURE Black pen: Micron 03, Sakura. Green and purple pens: ZIG Writer, EK Success. Chalks: Craf-T Products.

Aa Bb Cc Dd
Ee Ff Gg Hh
Ii Jj Kk Ll
Mm Nn Oo Pp
Qq Rr Ss Tt
Uu Vv Ww
Xx Yy Zz 1 2
3 4 5 6 7 8 9

Concave

The Concave alphabet combines curly lines with thick spaces that curve in at the center and out at the edges. To create this fluid font, first pencil the letters, then add lines on both sides to create fill-in spaces. For the concave effect, curve each line inward as it nears the center of the thick space, then out again. Opposite the thick space, curl the end of one part of the letter. Outline the letters with a medium- to thick-point pen. Concave holds patterns well, as in the "Family" sample.

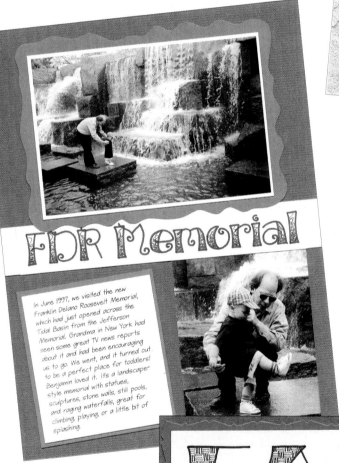

DIANA & DAN Black outline: ZIG Millennium 08, EK Success. Pencils: Memory Pencils, EK Success. Paper: Paper Pizazz, Hot Off the Press. Corner rounder: Marvy Uchida.

FDR MEMORIAL Black outline: Marvy Artist. Pen: Marvy Le Plume, No. 29 Prussian Blue. Font: CK Print, "Best of Creative Lettering" CD, Creating Keepsakes.

FAMILY Black outline: ZIG Writer, EK Success. Blue and purple detail: ZIG Millennium (005), EK Success.

ALPHABET · FILL-IN STRUCTURE Black pen: Marvy Medallion 08. Pencils: Memory Pencils, EK Success.

Aa Bb Cc Dd
Ee Ff Gg Hh
Ii Jj Kk Ll
Mm Nn Oo Pp
Qq Rr Ss Tt
Uu Vv Ww
Xx Yy Zz 1 2
3 4 5 6 7 8 9

Flair

Crisp as an arched eyebrow, confident as a sly wink, Flair's an alphabet with a trick or two up its sleeve. Just when you think you've got it figured out, it throws you a curve.

Before beginning, note that Flair uses four different types of serifs. Sometimes a line ends in a pointed swirl; sometimes in a short, flat serif; sometimes the serif extends beyond the letter's edges; and sometimes it just ends.

Each letter features at least one thick section for color. These sections can be straight-edged or softly rounded, like the right and left-hand stems of "A." In circular letters, the section is formed by running a second line on the inside of the curve, then denting it in its middle so that the shape resembles a boomerang. Still other sections fan out into small triangles, as in the hook of "g" or the leg of "K."

After surveying the shapes of the samples, pencil your letters' frames including the curls. Reshape the vertical spaces so they're wider and angular (see pp. 6 and 7). Outline the final shapes in ink, and erase any leftover pencil marks. Color with pen, chalk, or pencil.

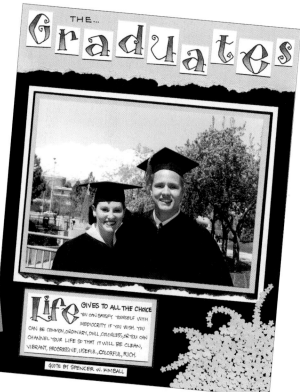

The 2nd Annual

Jazz Gala and Benefit Auction

For the Reggio Emilia Charter School

Saturday, March 20, 1999
7:00pm – 10:30pm
Sewall-Belmont House
144 Constitution Ave NE, DC

Advance Tickers $15.00 Supporters $20.00 at door

JAZZ GALA Black outline: Micron 03, Sakura. Red pencil: Prismacolor, PC924 Crimson Red, Sanford. Roses paper: Paper Pizazz, Hot Off the Press. Font: Technical (Corel).

NEW BABY Black outline: Micron 08, Sakura. Pencil: Prismacolor, PC937 Tuscan Red, Sanford. Mulberry paper: Personal Stamp Exchange. Paper: Close to My Heart. Rubber stamp: Personal Stamp Exchange. Other: ribbon.

THE GRADUATES Black outline: Micron 05, Sakura. Pencils: Prismacolor, PC1031 Henna and PC1018 Pink Rose, Sanford. Black pen for quote: Micron 005, Sakura. Flower punch: Family Treasures.

ALPHABET • ANGULAR STRUCTURE Black pen: Micron 03, Sakura. Pen: ZIG Writer (Blue Jay), EK Success.

Aa Bb Cc Dd

Ee Ff Gg Hh

Ii Jj Kk Ll

Mm Nn Oo Pp

Qq Rr Ss Tt

Uu Vv Ww

Xx Yy Zz 1 2

3 4 5 6 7 8 9

Bouquet

An abundance of blossoms bursts forth from the Bouquet alphabet, making this font one of the simplest and sweetest, suitable for a wedding scrapbook page or bridal shower invitation.

Begin by drawing the letters in pencil. Keep letters wide, then choose a vertical area on each letter for the bouquet. To make the bouquet, first draw a tight zigzag line—for the ribbon—at roughly the center point of the vertical area. Add about five flower stems. To make the bouquet more lifelike, draw the stems in loose, bending lines and vary their lengths, making some shorter and some longer than the others.

The rest of the letter should be straight-forward, with thin lines and flat serifs. In ink, outline the form of the letter except for its bouquet, which will be in color. Trace over the stems in a shade of green; for the ribbon, use a color to match or complement the blossoms.

Choose one to three colors for the flowers, and make clusters of dots at the top of each stem. Alternatives to flowers, such as grain or hay, are great for autumn themes; to create the sheaves, instead of drawing dots, add short lines on an upward slope from the stems.

BOUQUET

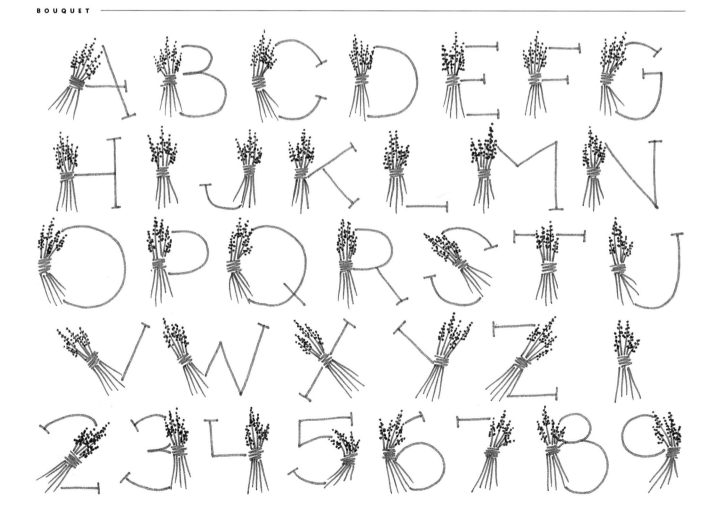

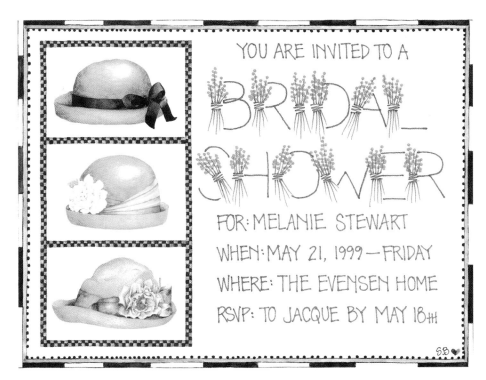

YOU ARE INVITED TO A

BRIDAL
SHOWER

FOR: MELANIE STEWART

WHEN: MAY 21, 1999 — FRIDAY

WHERE: THE EVENSEN HOME

RSVP: TO JACQUE BY MAY 18th

SB♥

BRIDAL SHOWER Pens: ZIG Writers (Wheat, Evergreen, and Coffee), EK Success. Stationery: Susan Branch, The Lovelace Co. Ltd.

JOSH AND BRIGITTE Pens: ZIG Writers (Chocolate, Hunter Green, and Plum Mist), EK Success. Decorative corners: K & Co. Rose leaf accents: Wallies, McCalls.

OLD & NEW Pens: Marvy Le Plume, No. 96 Jungle Green, No. 28 English Red, and No. 54 Burnt Umber. Wood paper: Frances Meyer. Leaf accents: Wallies, McCalls.

ALPHABET • SHAPES & MOTIFS STRUCTURE Pens: Marvy LePlume, No. 54 Burnt Umber, No. 96 Jungle Green, and No. 28 English Red.

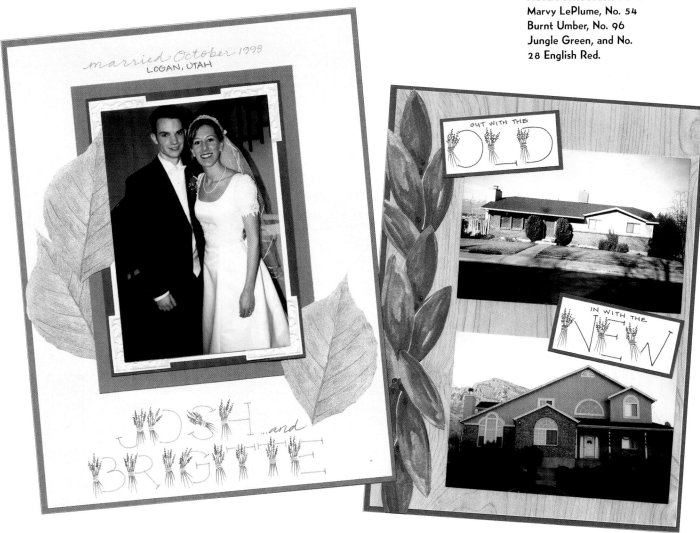

married October 1998
LOGAN, UTAH

JOSH ...and BRIGITTE

OUT WITH THE OLD

IN WITH THE NEW

Swirls

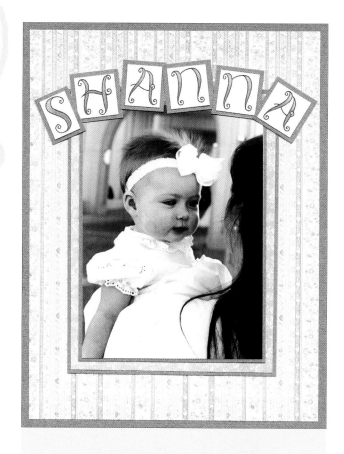

Like the little girl who had the little curl, Swirls can't keep itself from coiling up into wispy tendrils. There's hardly a straight line to be found in the entire alphabet.

To keep your letters well proportioned, print your letters first (see pp. 6 and 7). Then, write over every straight line with curves and curls, adding curly serifs wherever possible. Note that the curl at the top of the letter often coils opposite to the curl at the bottom. The letters also like to loop around their own lines—the crossbars in "H," for example.

To finish, add the wedges that will hold the color by extending lines from the frame. Outline in dark-colored ink. Shade the wedges with creamy chalks or soft pencils. If there's room, use more than one color in each letter, gradually fading from dark to light.

SHANNA Black outline: Micron 03, Sakura. Pencils: Prismacolor, PC1021 Jade Green and PC1025 Periwinkle, Sanford. Decorative paper: Mini Graphics.

A COMFORTABLE BRIDE Black outline: Micron 01, Sakura. Purple pen: ZIG Writer (Plum Mist), EK Success. Decorative corners: Pebbles in my Pocket. Pressed flowers: Nature's Pressed. Fun tip: Adhere the flowers to the cardstock with Delta photo-safe glue and a paintbrush.

MALLORY Black outline: Micron 01, Sakura. Pen: ZIG Writer (Sagebrush), EK Success. Stationery card: Frances Meyer.

ALPHABET • CURLY STRUCTURE Black outline: Micron 02, Sakura. Pen: ZIG Writer (Burgundy), EK Success.

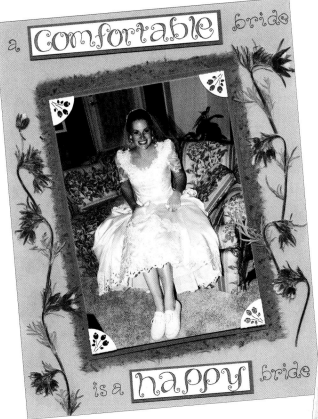

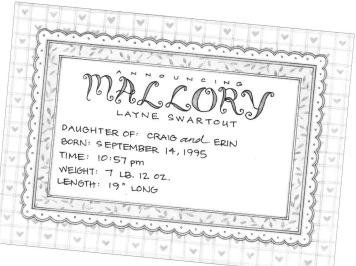

Aa Bb Cc Dd

Ee Ff Gg Hh

Ii Jj Kk Ll

Mm Nn Oo Pp

Qq Rr Ss Tt

Uu Vv Ww

Xx Yy Zz 12

3 4 5 6 7 8 9

Leafy Capitals

Tendrils twist up the trellislike sides of Leafy Capitals, where fresh green shoots sprout with the promise of spring.

Following the sample alphabet, pencil letters with thicks and thins. To make the vine, weave a line under and over the main thick space of the letter. Add the wavy serifs and the occasional curl. Review the shape of each letter and erase any leftover pencil marks.

Before adding leaves, practice making them on scrap paper: With a brush-tip pen, place the pointed tip on the page and gently press down to the back of the brush. Do not slide or move the brush—just touch and push. To color

your title, begin by tracing the vine lines in green ink with a fine-tip pen, then add the small, teardrop-shaped leaves with the brush pen. Or, you can outline the leaves with a fine-point pen (black or green), then color them with chalk or a colored pencil. Outline the rest of the letter with a fine-point pen, in black or another color.

Shade the thick spaces of Leafy Capitals with colored pencils from the same color family. The accent here is on the leaves—patterns in this font would be distracting.

LEAFY CAPITALS

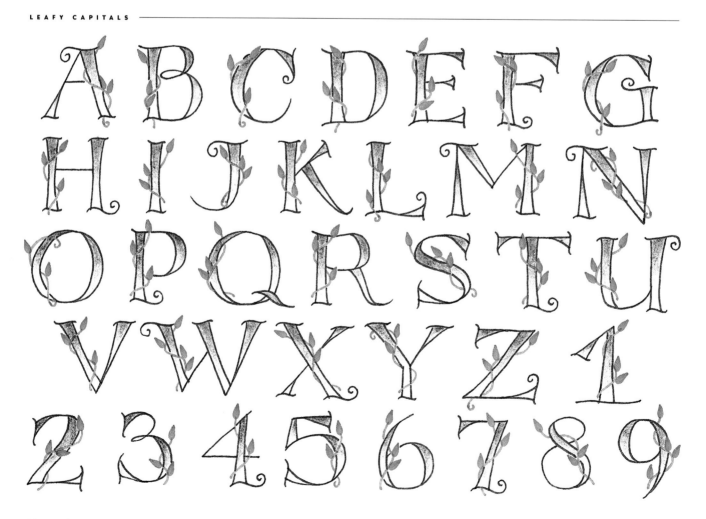

WEDDING Black outline: ZIG Millennium 03 EK Success. Green vine and leaves: Marvy Le Plume, extra-fine and brush tips, No. 96 Jungle Green. Chalk: Craf-T Products, (Burnt Sienna).

APRIL 1997 Black outline: Micron 02, Sakura. Vine and leaves: Marvy Le Plume, No. 96 Jungle Green. Pencil: Prismacolor, PC 1020 Celadon Green, Sanford. Paper: Paper Pizazz, Hot Off the Press. Leaf accents: Wallies, McCalls. Silver corners: 3L.

HAPPY MOTHER'S DAY Pens: ZIG Writers (Evergreen and Coffee), EK Success. Pencils: Memory Pencils, EK Success. Stickers: Susan Branch, The Lovelace Family Ltd.

ALPHABET • FILL-IN STRUCTURE Black outline: ZIG Millennium 03 EK Success. Green vine: EK Success ZIG Writer (fine tip), Evergreen. Green leaves: ZIG Scroll & Brush (brush tip, Evergreen), EK Success. Brown pencil: Memory Pencils, EK Success.

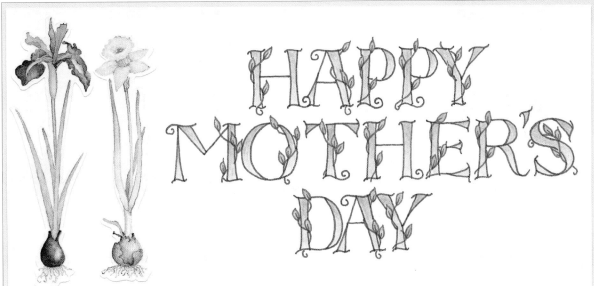

Hearts

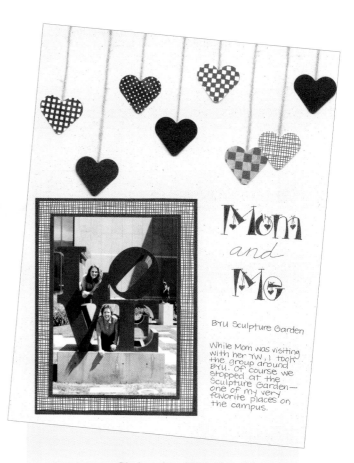

BYU Sculpture Garden

While Mom was visiting with her YW, I took the group around BYU. Of course we stopped at the Sculpture Garden—one of my very favorite places on the campus.

A delicate valentine dangles from most letters in the Hearts alphabet. Unabashedly romantic, Hearts is the font for the most tender moments—between sweeties, husband and wife, mother and child.

Narrow, triangular spaces and straight, flat-top serifs make up each letter in this skinny alphabet. When penciling the title, remember that it's not necessary to hang a heart on every letter. In most, but not every case, the heart is strung from a horizontal section of a letter.

After reviewing the shape of each letter, use a fine-point pen to outline the letters and an extremely fine-tip pen to outline the hanging hearts and their bows. Rich, solid colors work well for the hearts. But you can also use shades of the same color and vary the colors of the hearts, as shown in the "Happy Valentine's Day" example.

MOM AND ME Black outline: ZIG Millennium 03 and 005, EK Success. Red pen: ZIG Writer, EK Success. Heart punch: Family Treasures. Pattern paper: Keeping Memories Alive, Paper Patch and Northern Spy. Other: Rope.

PROM 1997 Black outline: Micron 01 and 05, Sakura. Purple pen: Marvy Artist, No. 8 Violet. Font: CK Print, Best of Creative Lettering CD, Creating Keepsakes. Daisy paper: Paper Pizazz, Hot Off the Press. Fun tip: Use a craft knife to silhouette a couple of daisies on the paper and overlap them on top of the pictures.

HAPPY VALENTINE'S DAY Black outline: Micron 03 and 005, Sakura. Pencils: Prismacolor, PC904 Light Cerulean Blue, PC908 Dark Green, PC937 Tuscan Red, and PC917 Sunburst Yellow, Sanford. Border stickers: Frances Meyer.

ALPHABET • FILL-IN STRUCTURE Black pens: ZIG Writer and ZIG Millennium 005, EK Success. Pencil: Prismacolor, PC924 Crimson Red, Sanford.

Brian came to pick me up at about six and he looked very handsome. My parents took pictures and we went to his house and his parents took a video. Then... we were off. We had dinner at Gondola at Gainey Ranch. We had valet parking. Gainey Ranch was so elegant and beautiful. The restaurant was very quaint and small. As we were walking in, the waiters sang some fun songs about eating and about the restaurant. Dinner was fantastic. We both had spaghetti with chicken and bread. Our waitress sang to us at our table. It was so romantic! She sang "Downtown." After dinner we were going to take a Gondola ride, but the wait was too long, so we are going to save our tickets for another time.

After dinner, we went to Prom, which was held on the 37th floor of the Bank One building downtown. We only stayed until about 11 o'clock (because I was so sick with a cold, cough, and no voice) and we drove back to Scottsdale for our carriage ride. It was peaceful and relaxing just to be sitting there with Brian close by. After that he brought me home and I slept the entire way. In my journal I noted, "It was such a fun time and I felt like such a princess. Brian had planned and done everything that I'd always dreamed about doing."

Aa Bb Cc Dd
Ee Ff Gg Hh
Ii Jj Kk Ll
Mm Nn Oo Pp
Qq Rr Ss Tt
Uu Vv Ww
Xx Yy Zz 1 2
3 4 5 6 7 8 9

FESTIVE alphabets

Party time! Festive alphabets don't discriminate—it's an open house, and everyone's invited to watch these high-energy letters. Checks blinks any assortment of colors; Voluptuous pulls out all the stops; Southwest spices it up; and Stitches falls apart at the seams. Festive alphabets may have strong personalities and seem elaborate in their presentation, but they're easy to learn. And because most of the Festive alphabets include ample room for coloring, different hues can significantly alter the feeling. Such adaptability makes Festive fonts some of the most versatile in this book, second only to Basic fonts. So when you want to make a statement, say it with a Festive alphabet.

Checks

Every letter in the Checks alphabet gets its own bright band of color. Pick a combination that sets the mood or complements the photos: Red and white stripes make holiday candy canes; orange and black bring Halloween to mind. The options are endless. Try two to four colors. Five or more can be overwhelming.

As you begin penciling the letters, note that the fine lines don't quite touch the spots where the checks will be: The wide, round bellies of letters such as "D" and "g," and the low, dropped waist of "A" and "H." On the section of the letter that will hold the checks, draw parallel lines on both sides of the original line. Erase the original line running down the center, and close off the two remaining bars to form a rectangle. Then add evenly spaced horizontal lines to make the boxes. The number of boxes will depend on the size of the letter.

To complete Checks, outline each letter with a fine-point pen and add a small dot at the end of each line. (Or, to vary it, leave out the dots and outline with a thick pen.) Then color the checks to your heart's content.

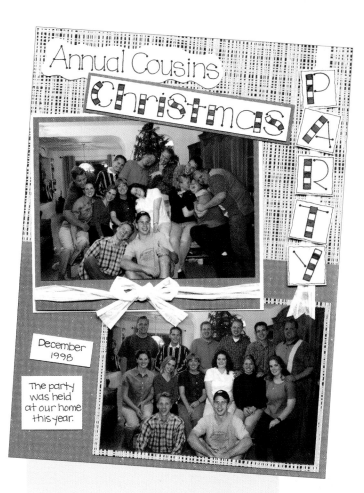

December 1998

The party was held at our home this year.

CHRISTMAS PARTY Black outline: Micron 03, Sakura. Pens: Marvy Le Plume, No. 29 Prussian Blue and ZIG Writer (Powder Blue), EK Success. Decorative paper: The Robins Nest. Raffia: Raffia Accents, Plaid.

SLUMBER PARTY Black outline: Micron 03, Sakura. Pencils: Prismacolor, PC993 Hot Pink and PC924 Crimson Red, Sanford. Stickers: Stickopotamus.

SCIENCE FAIR Black outline: Marvy Artist. Memory Pencils, EK Success.

ALPHABET • SHAPES & MOTIFS STRUCTURE (SEE P. 44) Black outline: Marvy Medallion 01. Pens: ZIG Writer (Splash and Clover), EK Success.

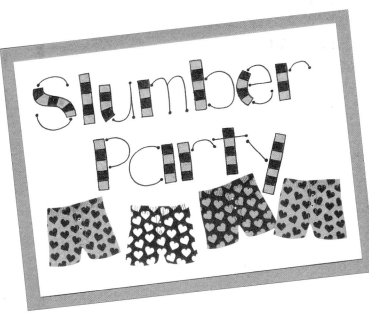

Aa Bb Cc Dd Ee
Ff Gg Hh Ii Jj
Kk Ll Mm Nn Oo
Pp Qq Rr Ss Tt
Uu Vv Ww Xx Yy
Zz 1 2 3 4 5 6 7 8 9

CONTEMPORARY CAPITALS

ABCDEFG
HIJKLMN
OPQRSTU
VWXYZ
123456789

Contemporary Capitals

Graceful, curlicued, and curvaceous, these fluid letters lend themselves to black-tie affairs. But they are also versatile and can be dressed down for casual occasions.

Begin lettering by lightly penciling in broad, wide letters. Then, start to add the thick block of color: On both sides of the section that will support the block, sketch a parallel line. After completing the outline, erase the original straight line in its center. For oval letters, such as "G" and "Q," draw a curved line down the middle.

Almost every letter has a swirl on the end. Lucky "M" and "S" get two. Sometimes, as in "B" and "P," the line swirls up instead of connecting with the color block. Other times, the curve of the swirl means you have to redraw one part of the letter: The arm of "E," for example.

Trace the letter in pen, then fill in half of each block with one color. Use a different color or pattern for the remaining half. Consistency is key for a unified, legible heading.

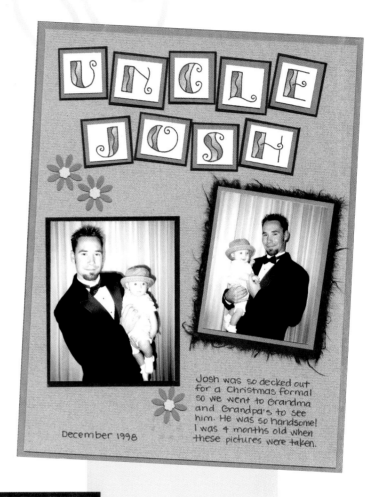

Josh was so decked out for a Christmas formal so we went to Grandma and Grandpa's to see him. He was so handsome! I was 4 months old when these pictures were taken.

December 1998

UNCLE JOSH Black outline: ZIG Writer, EK Success. Pencil: Prismacolor, PC988 Marine Green. Daisy punch: Family Treasures. Small flower punch: McGill. Mulberry paper: Personal Stamp Exchange.

NEW CAR Black pens: Micron 05 and 08, Sakura. Red pen: ZIG Scroll & Brush, EK Success. Paper: Paper Patch.

ALPHABET • FILL-IN STRUCTURE Black outline: ZIG Writer, EK Success. Blue and yellow pens: Marvy Le Plume, No. 75 Sky Blue and No. 5 Yellow.

Voluptuous

Like a three-day weekend, Voluptuous has something extra—not just one block of color, not just one graceful curl, not just any old serif.

Draw the letters with straight and curved lines, extending them when necessary to create a curl (see pp. 6 and 7). Each letter has one major and at least one minor section for color. (Minor spaces are created wherever the letter curves.) Form the bigger sections on the left, making one end wider than the other. Close each column with a wavy line on top and bottom, and allow it to flair out on both sides for an elegant lilt.

After inking, Voluptuous can be colored a delicate pattern or a solid color. To get the effect shown in the sample alphabet, use one pencil, allowing the color to fade. For the "Arizona Sunsets" effect, choose two pencils of complementary colors, blending them toward the center. Practice on scrap paper: The outcome is worth the extra minutes.

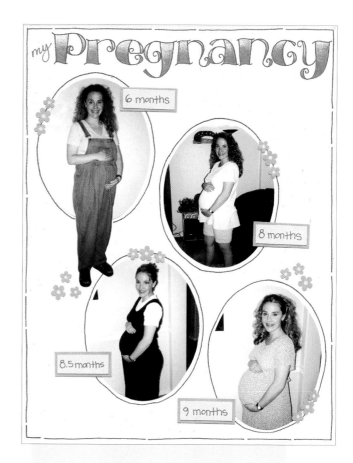

PREGNANCY Black outline: Marvy Artist (fine tip). Pencil: Prismacolor, PC903 True Blue, Sanford. Flower punch: McGill (corner punch). Yellow middles: ZIG Opaque Writer (Pure Yellow), EK Success.

ARIZONA SUNSETS Black outline: Micron 08, Sakura. Pencils: Prismacolor, PC937 Tuscan Red and PC1002 Yellowed Orange, Sanford. Pen for journaling: Micron 05, Sakura. Sunflower paper: Paper Adventures. Fun tip: The black horizon was re-created with torn black cardstock.

MICHELE Black outline: Micron 03, Sakura. Watercolor: Staedtler (3 shades of green). Green pencil for skinny spaces in lettering: Memory Pencils, EK Success.

ALPHABET • FILL-IN STRUCTURE Black outline: ZIG Writer, EK Success. Pencil: Prismacolor PC930 Magenta, Sanford.

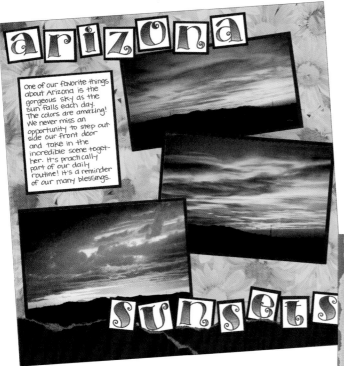

Aa Bb Cc Dd
Ee Ff Gg Hh
Ii Jj Kk Ll
Mm Nn Oo Pp
Qq Rr Ss Tt
Uu Vv Ww
Xx Yy Zz
1 2 3 4 5 6 7 8 9 0

Slice

Imagine a tiny tightrope walker treading his way through each letter of the Slice alphabet, steadying himself with his long, bending balance pole. Keep this acrobat in mind, and the Slice font won't be so intimidating. In fact, the slash mark is the final touch to an otherwise straightforward alphabet.

Most letters in Slice are rectangles that have been sliced in half. Round letters are composed of half-circle spaces and curved lines. Following the sample alphabet, write out the word or phrase, adding square serifs on each end of every line. Keep the squares big enough to eventually hold a spot of color, and note that they just barely touch the thick block.

After finishing the edges of the rectangular spaces, slice through each one with a slightly curved line. The slice can go in any direction. For a more formal look, contain the slice line within the borders of the thick block. Because it's already so busy, Slice sometimes looks best when shaded with two similar colors. Using colored pencils, pens, or watercolors, fill in both halves of each letter's thick section, and don't forget the squares!

DANCE RECITAL Black outline: Micron 05, Sakura. Watercolor: Staedtler. Brown pen (scribble): ZIG Millennium 01, EK Success. Deckle-edge scissors: Family Treasures.

GRADUATION GALA Black outline: Micron 05, Sakura. Color pencils: Prismacolor, PC995 Mulberry, PC902 Ultramarine, and PC907 Peacock Green, Sanford. Handmade paper: Craf-T Pedlars.

BONFIRE Black outline: Micron 05, Sakura. Pens: Marvy Le Plume, No. 7 Orange and No. 43 Brilliant Yellow. White opaque pen: Sailor. Hole punch: McGill. Other: Rope.

ALPHABET •FILL-IN STRUCTURE Black outline: Micron 03, Sakura. Pencils: Prismacolor, PC989 Chartreuse and PC912 Apple Green, Sanford.

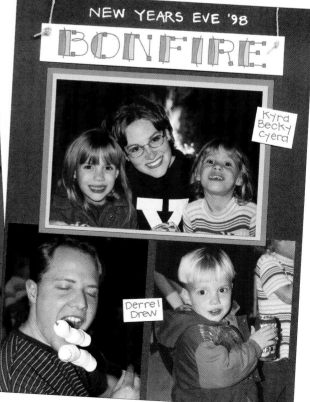

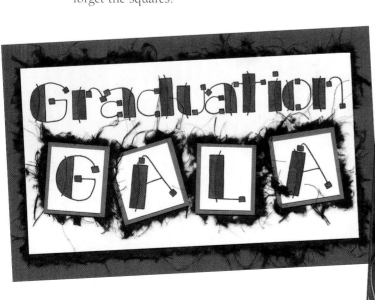

Aa Bb Cc Dd
Ee Ff Gg Hh
Ii Jj Kk Ll
Mm Nn Oo Pp
Qq Rr Ss Tt
Uu Vv Ww
Xx Yy Zz 12
3 4 5 6 7 8 9

Gala

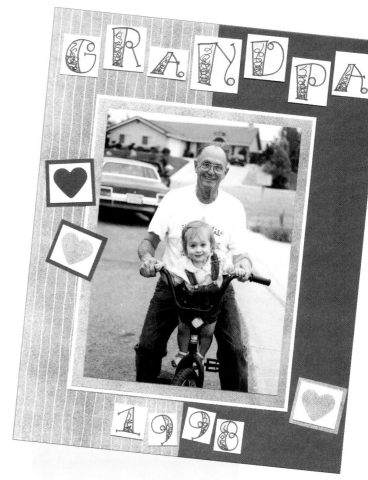

Dappled with dreamy colors or filled in with a cheerful pattern, happy-go-lucky Gala brightens up a page with its playful circle serifs that you can color in a variety of imaginative ways.

Begin, in pencil, by evenly spacing the letters in your word or phrase. Curve some lines according to the sample alphabet (notice the fluid right stems of "N" and "W"). Build the tapered block that will contain the color by running two lines along either side of the straight, left-hand stem. Start the lines close to the original line and gradually widen the angle outward. For variety, alternate widths, sometimes putting the narrower sides on the top and sometimes on the bottom. Note that the spaces in rounded letters are formed as half-moons inside their curves.

Most letters and numbers have at least one circle serif; simply draw them at the ends of curving lines as shown in the sample alphabet. Make sure to keep the circle serifs very open and round. Remember: The serifs should be circles, not ovals, to get the right look. Cap the single lines and the lids of the blocks with short, flat serifs, extending them slightly beyond the edge. Letters "T" and "X" use this technique.

To create a hazy cloud of soft colors for the Gala font choose chalks, color pencils, or watercolors.

GRANDPA 1998 Black outline: Marvy Medallion 05. Blue pens: ZIG Writers (Powder Blue and Navy), EK Success. Paper: Close to My Heart. Heart punch: Marvy Uchida.

PICNIC Black outline: Marvy Artist (fine tip). Red pen: ZIG Writer (fine tip), EK Success. Chalk: Craf-T Products, Red.

ALPHABET • FILL-IN STRUCTURE Black outline: ZIG Writer (fine tip), EK Success. Chalk: Craf-T Products, Dark Blue.

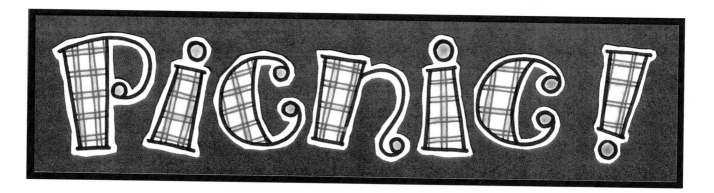

Aa Bb Cc Dd
Ee Ff Gg Hh
Ii Jj Kk Ll
Mm Nn Oo Pp
Qq Rr Ss Tt
Uu Vv Ww
Xx Yy Zz 1 2
3 4 5 6 7 8 9

Southwest

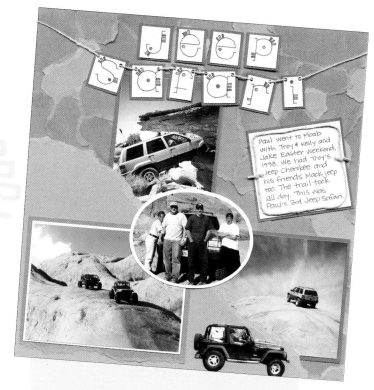

Southwest's letters sprout feathers, then peer out from the page with one roving eye. Stark and primitive, Southwest looks simple, but it calls for a steady hand.

Keep lines straight except for round letters, which should have circles as wide open as the Wild West itself. Short, flat serifs jut from the ends of each line, often facing outward, less frequently pointing inward. Either way, the result is a small, neat corner.

Once the basic frame of the letters is drawn, look it over to determine how many feathers to add, and where to place the eye. Use the samples as a springboard, and play with different options, adding and erasing at the pencil sketch stage. The Southwest alphabet is not carved in stone! Remember that the rectangle and circle accents are mobile. The waists of the alphabet should be either very high or very low to complement the rounded parts of the letter.

JEEP SAFARI Black pen: Micron 05, Sakura. Pens: ZIG Writers (Chocolate, Burgandy, and Wheat), EK Success. Hole punch: McGill. Other: Rope. Fun tips: Scraps of paper were used to create the background. Also, letters were "hung" at the top by stringing rope through punched holes in each block.

GIRLS NIGHT OUT Black pens: Micron 03 and 05, Sakura. Pens: ZIG Writers (Sagebrush and Lavender), EK Success. Paper: Paper Patch. Fun tip: The flowers were cut from the decorative paper to accent the sign.

LIKE FATHER, LIKE SON Black outline: Micron 05, Sakura. Pens: Marvy Le Plume, No. 75 Sky Blue and No. 11 Light Green. Pop dots (for letter blocks dimension): Pop-it-Up, Cut-it-Up.

ALPHABET • PRINT STRUCTURE Black pen: ZIG Millennium 05, EK Success. Yellow pen: ZIG Writer (Apricot), EK Success.

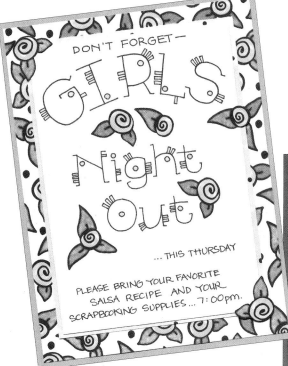

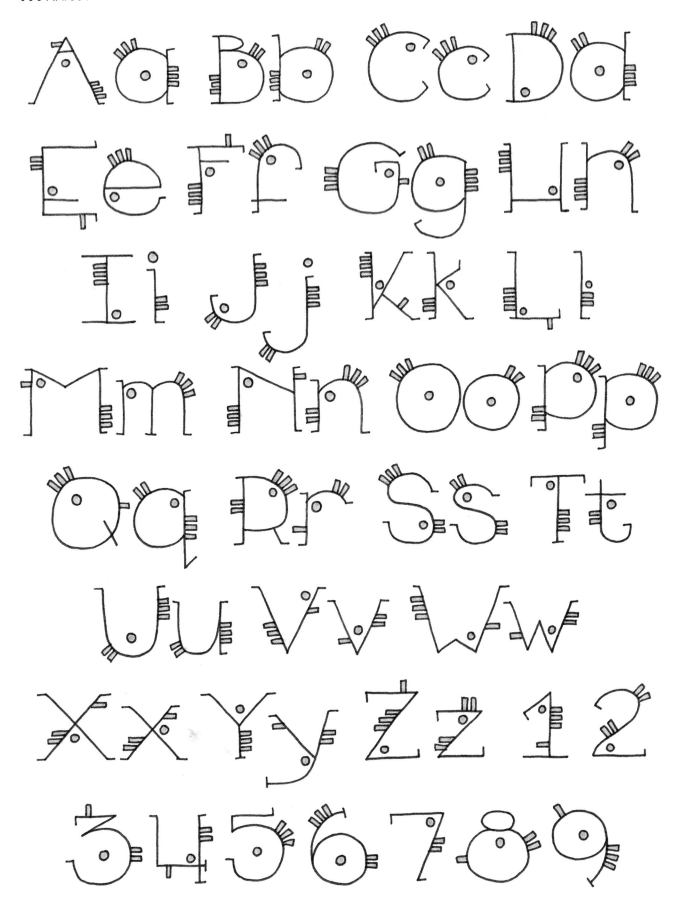

Choppy Block

Earthquake! Choppy Block shivers and quivers, rattles and rolls, instantly energizing a subject, be it baby's wobbly first steps or a nerve-wracking rock-climbing expedition. Because it's so exciting, use just one color for filling in. If you use a pattern, give the letters lots of room. Consistently sized letters hold this alphabet together.

A shaky alphabet takes a steady hand. Begin by lightly drawing block letters over basic pencil lines (see pp. 6 and 7). Then, jut into and out of the standard borders to create deep dents and jagged edges. When you're satisfied, erase the block letter, so that only the Choppy Block shape remains. Trace over the results in pen. Use a finer-point pen to add shadow lines for the quaking effect.

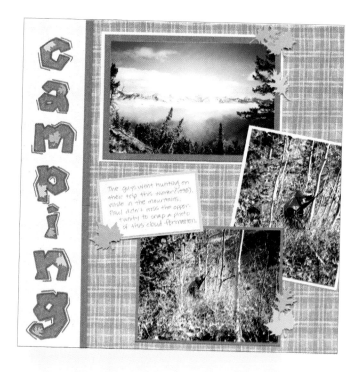

CAMPING Black outline: Marvy Artist. Color pencil: Prismacolor, PC908 Dark Green, Sanford. All leaf punches: Family Treasures. Paper: Keeping Memories Alive. Journaling: Micron 01, Sakura.

DALLIN Black outline: Micron 08 and 03, Sakura. Blue pen: ZIG Writer (Denim), EK Success. Black corners: 3L.

DORM LIFE Black pens: Micron 01 and 08, Sakura. Pens: Marvy Scroll & Brush, No. 2 Red, No. 11 Light Green, No. 7 Orange, No. 75 Sky Blue, and No. 5 Yellow.

ALPHABET • BLOCK STRUCTURE Thick black pen: Marvy Artist. Thin black pen: Marvy Medallion 03. Red pen: Marvy Le Plume, No. 2 Red.

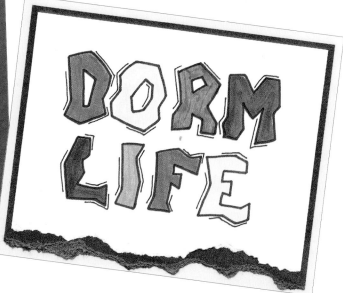

Aa Bb Cc Dd
Ee Ff Gg Hh
Ii Jj Kk Ll Mm
Nn Oo Pp Qq
Rr Ss Tt Uu
Vv Ww Xx Yy
Zz 1 2 3 4 5 6
7 8 9

Stitches

If the Mummy and Frankenstein's monster collided, Stitches might be the result. Try two or three different shades, or stick to black and white for an extra jolt. Solid colors are easiest—save patterns for big signs. Start with lighter colors; darker colored ink in the neighboring block will cover it up.

Stitches requires attention to detail, so be sure to sketch out each letter in pencil, referring to the sample alphabet. Note that the edges are a little squared, but not quite pointed.

For many letters, the thick spaces are adjoined to the left stem: On either side of the original line, run a second bar from one end to the other, expanding the width between the two as you go, then close them off at top and bottom. On rounded letters, such as "C" and "O," pencil a bent line inside the curve.

Finally, stitch up the thick spaces with two to four helter-skelter threads. Each stitch should extend just a bit beyond the border of the letter. Before outlining in ink, add a swirling spiral to the lines that don't have stitches and square off the edges of the curl.

LEMONADE Black outline: Mircon 08, Sakura. Pens: ZIG Writers, EK Success.

FAMILY. . .FRIENDS Black outline: Micron 05, Sakura. Pencils: Prismacolor, PC904 Light Cerulean Blue, PC906 Copenhagen Blue, PC1022 Mediterranean Blue, and PC1025 Periwinkle, Sanford. Paper: Colors by Design. Mounting tape (lifting up each letter block): 3M.

PARTY Black outline: ZIG Millennium 08, EK Success. Pencils: ZIG Memory Pencils, EK Success. Pens: ZIG Writers (Orchid and Spring Green), EK Success. Flower stickers: Stickopotamus. Wavy edge: Cut-it-Up ruler.

ALPHABET • ANGULAR STRUCTURE All pens: ZIG Writer (Black, Red, Orange, Summer Sun), EK Success.

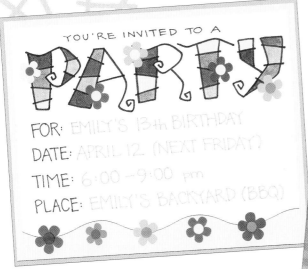

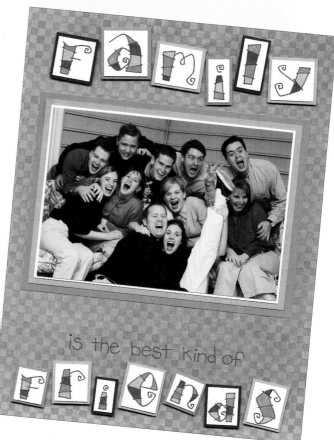

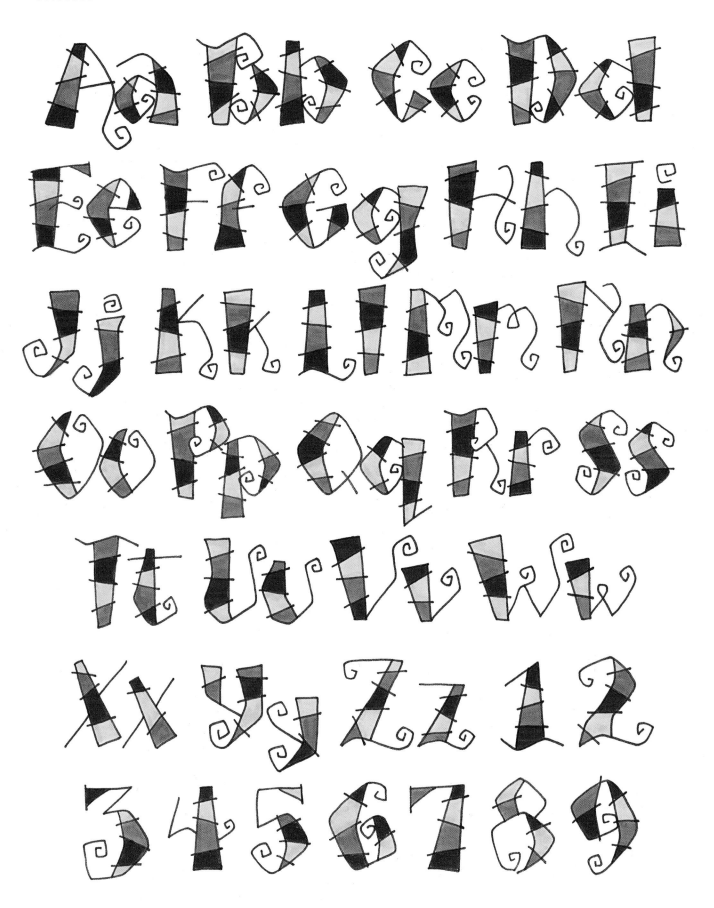

Delight

Warm as a woolen sweater, tall but not too narrow, Delight is an easy alphabet with a flexible ornamental feature—a stitched, soft-edged triangle.

Start by penciling in single-line letters. On the triangle side, along both sides of the original line, taper two straight bars that gradually fan out. Gently round the edges. Alternate triangles so one letter has the broad end at its bottom and the next at its top. Letters such as "O" and "S" have shapes that follow their curves.

After outlining in ink, you have the choice of adding tick marks or stitches inside the space with the finest-point pen possible. Pull the pen right to the edge with every stroke.

Every letter sports an energetic spiral. Start with a big oval just beyond the end of the letter and loop inward, like a tornado, until it blends into the line. Use a fine-point pen. Color with chalks, pencils, and pens to give Delight a muted look.

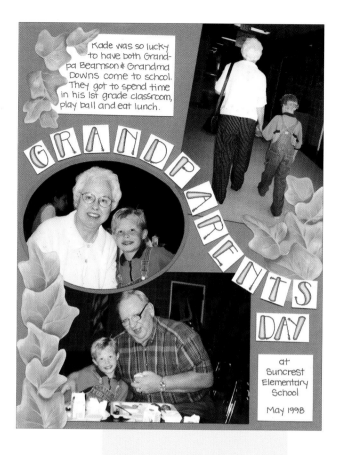

Kade was so lucky to have both Grandpa Beamson & Grandma Downs come to school. They got to spend time in his 1st grade classroom, play ball and eat lunch.

GRANDPARENTS DAY

at Suncrest Elementary School

May 1998

GRANDPARENTS' DAY Black outline: Micron 03, Sakura. Blue pens: ZIG Writers (Denim and Powder Blue), EK Success. Leaf accents: DMD Industries.

HAPPINESS Black outline: Micron 01 and 005, Sakura. Green pen: ZIG Writer (Spring Green), EK Success. Green pencil: Prismacolor, PC912 Spring Green, Sanford. Paper: Colors by Design.

BOOK CLUB Black pens: Micron 05 and 01, Sakura. Chalks: Craf-T Products. Paper: Northern Spy.

ALPHABET • FILL-IN STRUCTURE Black pens: ZIG Writer and ZIG Millennium 005, EK Success. Purple pencil: Prismacolor, PC931 Dark Purple, Sanford. Blender: Prismacolor, Sanford.

Aa Bb Cc Dd
Ee Ff Gg Hh Ii
Jj Kk Ll Mm
Nn Oo Pp Qq
Rr Ss Tt Uu
Vv Ww Xx Yy
Zz 1 2 3 4 5
6 7 8 9

Fiesta

Hot, hot, hot! An alphabet *muy caliente*, Fiesta letters are straight lines that meet to form a sharp point wherever the letter bends. Use busy Fiesta sparingly. Solid-color ink will keep it readable.

Lightly pencil the letters in single lines, allowing enough room for the pointed spaces that will hold color. Extend two lines along the length of either side, as in "L" and "V." Taper the lines so that the resulting block will be broader at one end. Close them off with flat serifs. Where the letter bends, create small triangles.

Erase pencil marks, pencil in quaking accents, and throw in sharp curls as in the low waist of "F." To outline, use a medium-point pen for the main frame, the same or finer-point pen for the quaking accents. Fill in with colored pens, and you're ready to party.

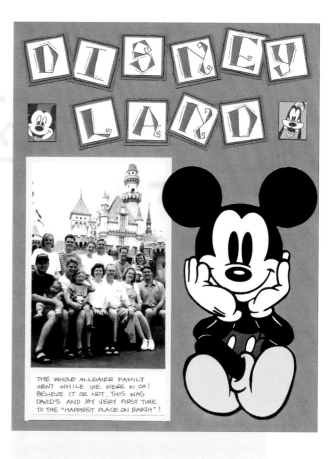

THE WHOLE ALLGAIER FAMILY WENT WHILE WE WERE IN CA! BELIEVE IT OR NOT, THIS WAS DAVID'S AND MY VERY FIRST TIME TO THE "HAPPIEST PLACE ON EARTH"!

DISNEYLAND Black pens: Micron 005 and 03, Sakura. Red pen: ZIG Scroll & Brush, EK Success. Large Mickey Mouse accent: ©Disneyland memorabilia. ©Disney motifs: cut from Paper Pizazz, Hot Off the Press paper.

HAVISUPAI FALLS Black pens: Micron 01 and 05, Sakura. Pencils: Prismacolor, PC0134 Goldenrod and PC944 Terra Cotta, Sanford. Paper: Wubie Prints.

SCRAPBOOK PARTY Black outline: Micron 03, Sakura. Thick black pen for "Party": ZIG Writer, EK Success. Pens: ZIG Writers (Splash, Clover, and Hot Pink), EK Success. Stickers: Stickopotamus. Paper: Jenny Faw, InterArt Distribution.

ALPHABET · ANGULAR STRUCTURE Pens: ZIG Writer (Black and Splash), EK Success.

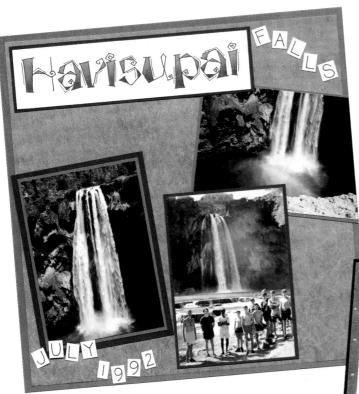

Aa Bb Cc Dd
Ee Ff Gg Hh
Ii Jj Kk Ll
Mm Nn Oo Pp
Qq Rr Ss Tt
Uu Vv Ww
Xx Yy Zz 1 2
3 4 5 6 7 8 9

FUNKY alphabets

Groovadelic, hypnotronic, discorific: Welcome to Funky town! Funky alphabets have such vibrant personalities, they often steal the show. You'll have to decide which projects can handle the wiggles that make up the shape of Funky Wave, the every-which-way motion of Arrows, or the jagged edges of Zigzag. But other Funky fonts are adept partners for just about any project. Geometric, as its name implies, can work any angle, and Split Box allows plenty of room for opposite colors to attract. So don't be shy. Let the Funky letters lead the way—but be sure you strut your stuff alongside these highly individual alphabets.

Arrows

Up, down, straight across town—let arrows point the way in this high-energy alphabet, where each letter is made out of arrows of varying widths.

Pencil your word or phrase in thin, wide lines: On the sections of each letter that will remain single lines, add the arrowhead serif. Then, referring to the sample alphabet, add the wide-width, two-lane, or wavy-line arrows.

To make wide-width arrows, such as the one featured on the left-hand stem of "B," draw a parallel line on either side of the original line, close off one end, and add the broad, triangular, pointed arrowhead to the other. If it's easier, first create a simple rectangle by closing off both ends of the thick space, then top one end with a triangle, allowing the base of the triangle to extend beyond the width of the rectangle. A ruler or stencil keeps lines straight, although they don't have to be perfect. To finalize the arrow shape, erase the horizontal line shared by the rectangle and the triangle, and the original line running down the center of the thick space.

To make two-lane arrows like the one seen on the left-hand stem of "L," draw two sets of parallel lines on either side of the original line. One set should be close to the original, center line; the other, farther apart. Erase the original, center line, and close off both ends of the two thin, parallel rectangles. Finish by adding a triangle to one end, noting that, for two-lane arrows, the triangle is a separate shape that floats close to but slightly above the two thin rectangles.

To make wavy-line arrows, in some cases all you have to do is replace the original, single straight line with a wavy, single straight line—as seen in lowercase "z." For broader wavy-line arrows, pencil a parallel set of wavy lines on either side of the original center line.

For even more variety, alternate the single-line arrowhead serifs with the freestanding triangles on the ends of the letters. After erasing any remaining pencil marks and outlining the final shapes in ink, finish up by shading the arrows with a solid color.

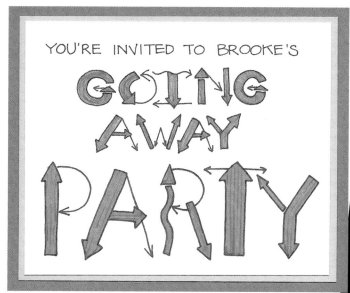

YOU'RE INVITED TO BROOKE'S
GOING AWAY PARTY

CAR WASH

TRUCKS $5.00

CARS $3.00

VANS & SPORTS UTILITIES $7.00

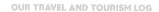

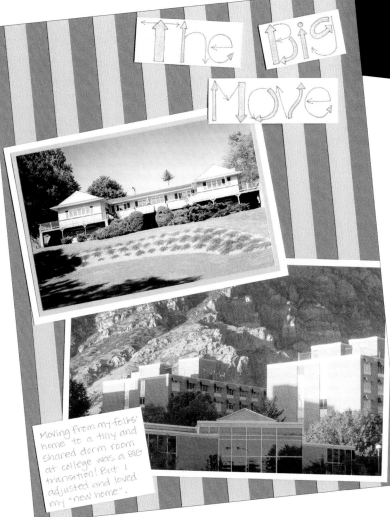

The Big Move

Moving from my folks' home to a tiny and shared dorm room at college was a BIG transition! But I adjusted and loved my "new home".

OUR TRAVEL AND TOURISM LOG
Black outline: Micron 08, Sakura. Green pencil: Memory Pencils, EK Success. Sticker border: Frances Meyer. Yellow striped paper: Design Originals.

CAR WASH Black and red pens: Marvy Artist.

GOING AWAY PARTY Black pen: Micron 01 and 03. Pen: ZIG Writer (Splash), EK Success.

THE BIG MOVE Green outline: ZIG Writer (Evergreen), EK Success. Green pencil: Memory Pencils, EK Success. Fun tip: The background was created with strips of lighter green on a darker green cardstock.

ALPHABET • UNIQUE All pens: ZIG Writer (Black and Apricot), EK Success.

Aa Bb Cc Dd
Ee Ff Gg Hh
Ii Jj Kk Ll
Mm Nn Oo Pp
Qq Rr Ss Tt
Uu Vv Ww
Xx Yy Zz 1 2
3 4 5 6 7 8 9

Funky Wave

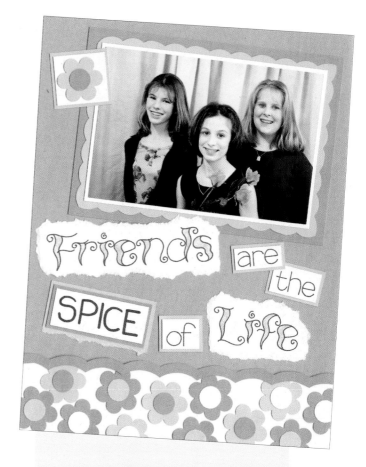

Wipeout! Surf the wave of this fluid, funky font, which features curves of color and charming, curly serifs. Funky Wave can be tricky, so if you have a light box, use it with the sample alphabet to trace the letters.

Begin by penciling the skeletal structure of each letter, noting the curves and wavy lines. To make the thick spaces, pencil a wavy line on either side of the original line. Taper the lines so they meet in a point at one end. Erase the original line, and cap the wavy section with an equally wavy serif that curls at one end and flairs out slightly at the other.

After completing the wavy section, add extra curly serifs to the ends of some of the simple lines—the crossbar of "A," for example. After outlining the shapes in ink, use color pencils or pens to shade and blend. The darkest shade should be concentrated at the pointed end.

FRIENDS ARE THE SPICE OF LIFE Black outline: Micron 05, Sakura. Thick black pen: ZIG Writer, EK Success. Green pencil: Memory Pencils, EK Success. Flower and circle punches: Family Treasures. Scallop scissors: Fiskars. Scallop edge at bottom of page: Rule-it-Up, Cut-it-Up.

GET WELL SOON Black outline: ZIG Writer, EK Success. Pencils: Prismacolor, PC988 Marine Green and PC1029 Mahogany Red, Sanford. Paper: Papers by Design.

HALLOWEEN Black outline: Micron 08, Sakura. Pencil: Prismacolor, PC1032 Pumpkin Orange, Sanford. Paper: Frances Meyer.

ALPHABET · CURLY STRUCTURE Black outline: ZIG Writer, EK Success. Blue pencil: Prismacolor, PC933 Violet Blue, Sanford. Blender: Sanford.

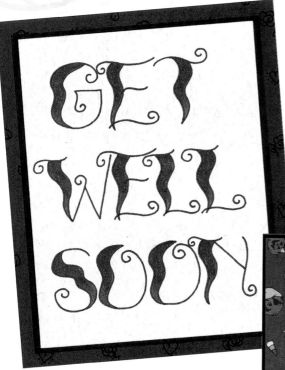

Aa Bb Cc Dd
Ee Ff Gg Hh
Ii Jj Kk Ll
Mm Nn Oo Pp
Qq Rr Ss Tt
Uu Vv Ww
Xx Yy Zz 12
3 4 5 6 7 8 9

Split Box

Night or day? Him or her? Chocolate or vanilla? Have both with Split Box, an alphabet that combines the best of two worlds by splitting each letter in half, thereby permitting two opposites to coexist within the same frame—a square or rectangular box.

Begin by writing slim Block Structure letters. Then, add the boxes that house the letters. Although you can freehand them, it may help to use a template of some sort: For example, pencil a square or rectangle on card stock, cut it out, and use this shape to trace out the boxes. (You may also want to try making the boxes before drawing the individual letters.) Also try cutting out more than one stenciled shape, to vary the sizes of the boxes ("Graduation"). And notice that, for added energy, the boxes can tilt forward and backward, instead of sitting flat.

After completing the block shapes, add the line that splits the box. You can draw one line at an angle, within the box's border, or, for a looser feel, the line can extend beyond the edges ("Park"). To break up the box into more sections for color, use two lines ("Our Home"). These lines don't have to be straight: Try crooked lines, too. After outlining in ink, use two, three, or four colors to shade the various sections within each box.

SPLIT BOX —————————————————————————

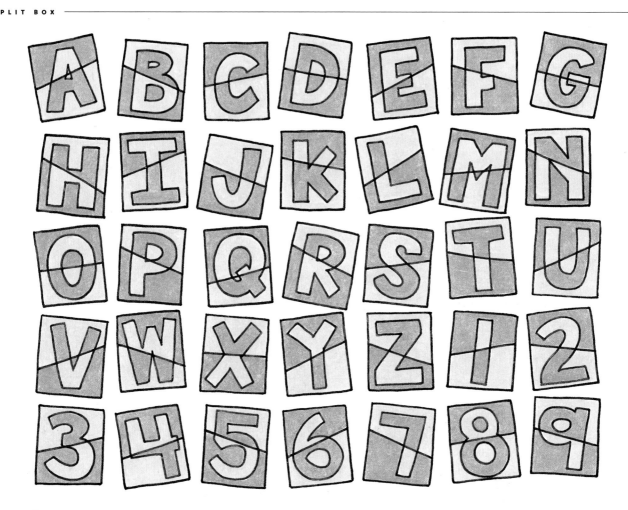

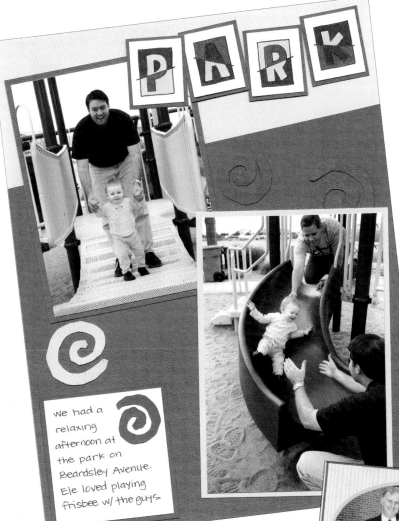

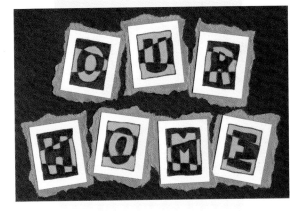

OUR HOME Black outline:
Micron 05, Sakura. Pencils:
Prismacolor, PC996 Black
Grape and PC1026
Greyed Lavender, Sanford.

PARK Black outline:
Micron 03, Sakura. Pencils:
Prismacolor, PC906
Copenhagen Blue, PC1005
Limepeel, and PC1031
Henna, Sanford. Swirl
accents: hand cut.

we had a
relaxing
afternoon at
the park on
Beardsley Avenue.
Ele loved playing
frisbee w/ the guys

GRADUATION Black
outline: Micron 08,
Sakura. Pens:
ZIG Scroll & Brush
(Red and Apricot), EK
Success. Paper: Keeping
Memories Alive.

**ALPHABET • BLOCK
STRUCTURE** Black outline:
ZIG Writer, EK Success.
Pencils: Prismacolor, PC989
Chartreuse and PC992
Light Aqua, Sanford.

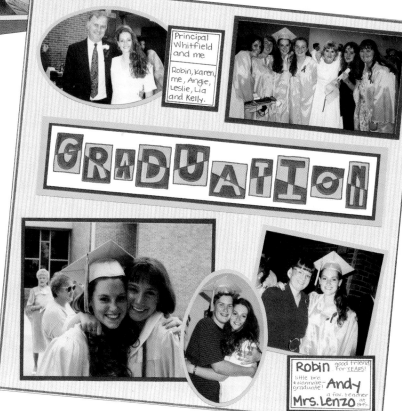

Principal
Whitfield
and me

Robin, Karen,
me, Angie,
Leslie, Lia
and Kelly.

Robin good friend for YEARS!
little bro
+ wannabe-
graduate- Andy
Mrs. Lenzo a fav. teacher at BHS.

Geometric

Take the basic forms you learned in math class and put them into words—literally!—with the Geometric alphabet. Like marshmallows stuck on a stick or cubes of food speared by a shish-kebab skewer, Geometric's shapes are sporadically strung on the single lines of each letter.

Pencil the word or phrase in wide, round lines (see pp. 6 and 7), then, referring to the sample alphabet, add geometric shapes—triangles, circles, and squares—here and there on the original lines. Allow the shapes to occasionally overlap so that, for example, the pointed end of a triangle is hidden under the round edge of a circle. Once the geometric shapes are in place, erase the bits of the original line running through their centers.

For an extra spurt of energy, add the sprouts—the groupings of three short lines—as accents. Note that these trios come close to, but don't touch, the original line.

Outline in black ink, beginning with the geometric shapes and the sprout accents (which can be colored in a complementary shade), then follow up with the single lines. Finish by coloring in the shapes.

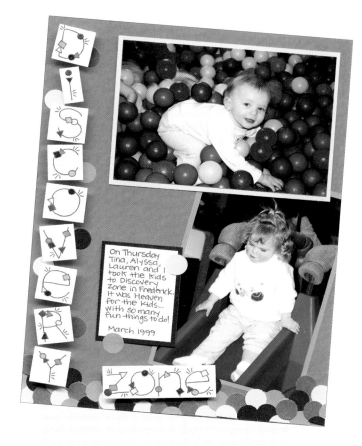

DISCOVERY ZONE Black outline: Micron 05, Sakura. All color pens: ZIG Writer (Red, Yellow, Blue Jay, Spring Green, and Orchid), EK Success. Circle punch: McGill. Pop dots: Pop-it-Up, Cut-it-Up.

GO TEAM Black and red pens: ZIG Writer, EK Success.

DOUBLE TROUBLE Black outline: Micron 08, Sakura. Pencils: Prismacolor, PC944 Terra Cotta, PC945 Sienna Brown, and PC946 Dark Brown, Sanford. Fun tip: Background created with strips of cardstock.

ALPHABET • PRINT STRUCTURE All pens: ZIG Writer (Black, Clover, and Splash), EK Success.

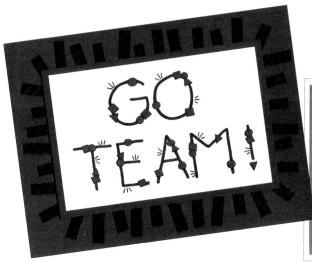

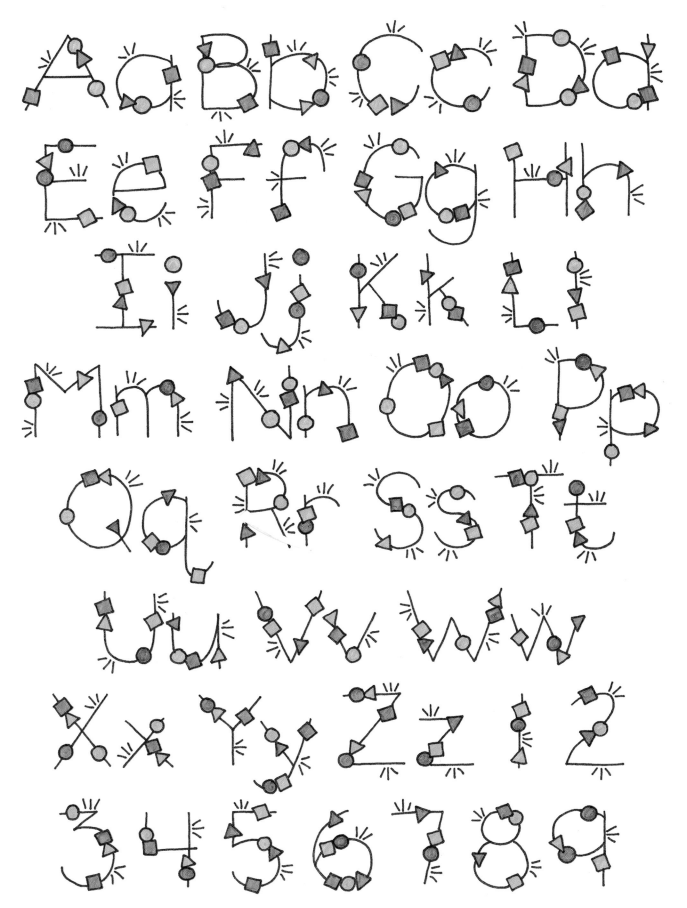

Zigzag

Add a saw-toothed edge to your titles with Zigzag, the alphabet that looks as if it's been snipped by pinking shears. Refer to the sample, and pencil the basic frame of each letter in your word or title. Then, get rid of all the curves: Add angles to the plain lines of the letters, as in "B" and "O."

To create the saw-toothed edge, simply draw a jagged line alongside one section of the letter, connecting it top and bottom to the basic frame. Finish the letters with a flat serif, or, less frequently, a pointy curl—as seen in the crossbar of "H."

Erase any leftover pencil marks, and outline the finished letters, serifs and all, with a fine-point pen. Shade the saw-toothed space with either a single, solid color ("Harley Girls"), or a combination of pencils ("Marathon Man") or chalks ("Las Vegas") in the same color family. The jagged edge of Zigzag letters would clash with a pattern.

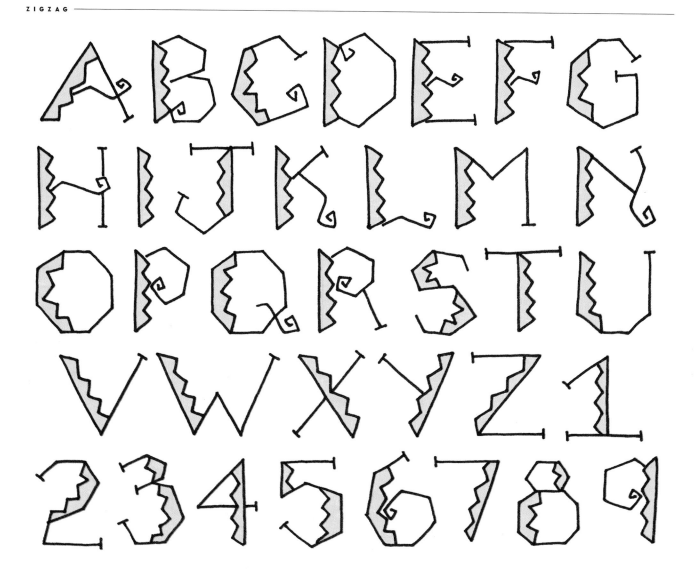

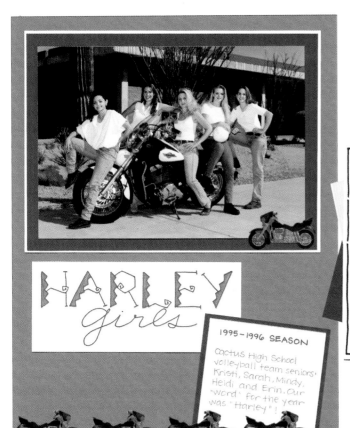

HARLEY
girls

1995-1996 SEASON

Cactus High School
volleyball team seniors'
Kristi, Sarah, Mindy,
Heidi and Erin. Our
"word" for the year
was "Harley"!

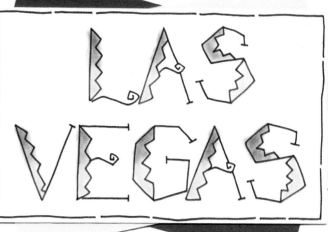

LAS
VEGAS

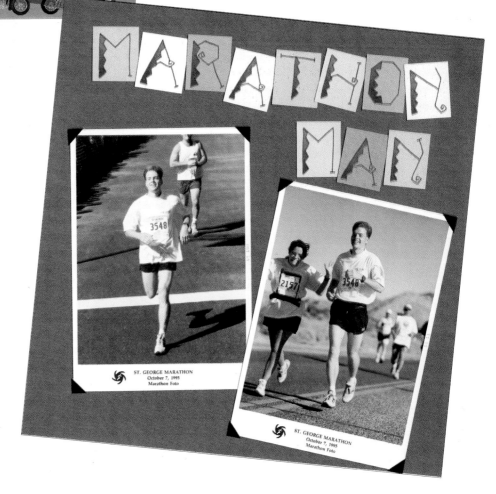

MARATHON
MAN

LAS VEGAS Black out-
line: Micron 08,
Sakura. Chalks: Craf-T
Products (Lime Green
and Dark Blue).

HARLEY GIRLS Black
pen: Micron 05,
Sakura. Blue pen:
ZIG Writer (Denim),
EK Success.
Motorcycle stickers:
Stickopotamus.

MARATHON MAN Black
outline: Micron 05,
Sakura. Pencils:
Prismacolor, PC937
Tuscan Red and
PC943 Burnt Ochre,
Sanford. Corners: 3L

**ALPHABET • ANGULAR
STRUCTURE** Pens:
ZIG Writer (Black and
Kiwi), EK Success.

Spiky Classic

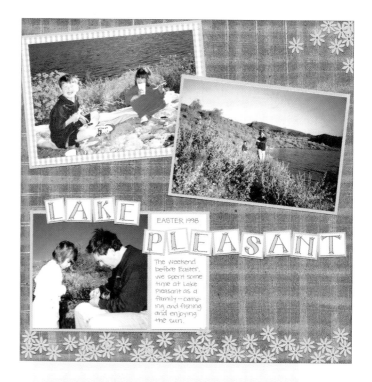

Elegant with a bit of funk, Spiky Classic combines lean color blocks with sprouts and inverted triangle accents. Like its namesake, the Classic alphabet, it features spaces for color and basic letter shapes.

In penciling the letters, allow room between them to add on the thick spaces. Triangles of color can be added to the ends of letters—the kicking leg of "K," for example. Create thick spaces by drawing parallel lines on either side of the original line. Close off the ends with the pointy concave serifs that house the accents that give the font its funkiness.

Add accents by drawing a trio of lines or a small triangle into the serif. Outline in black or dark-colored ink, using a finer-point pen and, if desired, a complementary color for the accents. Then color the thick spaces.

LAKE PLEASANT Black pens: Micron 001 and 03, Sakura. Yellow and Red pens: ZIG Writer (Summer Fun and Spice), EK Success. Blue plaid paper: Provo Craft. Yellow gingham paper: Design Originals. Daisy punch: Family Treasures.

HALLOWEEN 1978 Black outline: Micron 05, Sakura. Orange pencil: Memory Pencils, EK Success. Paper: Colors by Design.

HOLIDAY PARTY Black pens: Micron 02 and 05, Sakura. Pencils: Prismacolor, PC924 Crimson Red and PC937 Tuscan Red, Sanford. Red pen: Marvy Medallion 01. Paper: Keeping Memories Alive.

ALPHABET • FILL-IN STRUCTURE Black outline: ZIG Writer, EK Success. Light and dark purple color pencils: Memory Pencils, EK Success. Purple pen: ZIG Millennium 01, EK Success.

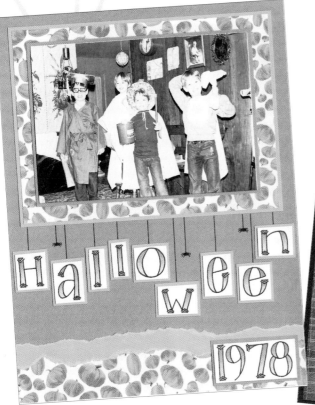

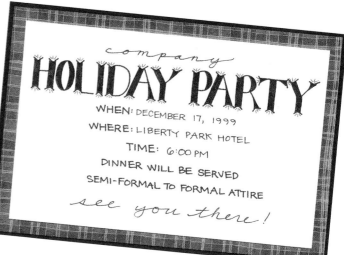

Aa Bb Cc Dd
Ee Ff Gg Hh
Ii Jj Kk Ll
Mm Nn Oo Pp
Qq Rr Ss Tt
Uu Vv Ww
Xx Yy Zz 1 2
3 4 5 6 7 8 9

Spiky Block

Rows of sharp teeth line the Spiky Block alphabet, making these letters a little rough around the edges. This alphabet conveys motion, movement, and big changes.

Begin by penciling the word or phrase in Block Structure letters. Next, roughly following the outline of the initial block letter, jut into and out of the borders to create deep dents, sharp corners, and squared-off edges. Compare your shapes to the sample alphabet, make any adjustments, and erase the remnants of the regular block letter, so that only the Spiky Block shape remains.

Add the spiky, toothed accents in some of the newly created nooks: Draw the base of the spiky shape, which can be either a short, straight line running parallel to the edge of a letter or a pointed "V" that fits into one of the dents in the block (for quick reference, check out "Q," which features both versions). Then top the base with two or three pointy teeth.

Trace over the results in ink, using the same or a finer-point pen for the spiky accents. When coloring the letters, play with the spiky accents: They can be the same color as the letter, a complementary shade, or even a pattern, as seen in "Kaulin's Last Day of School."

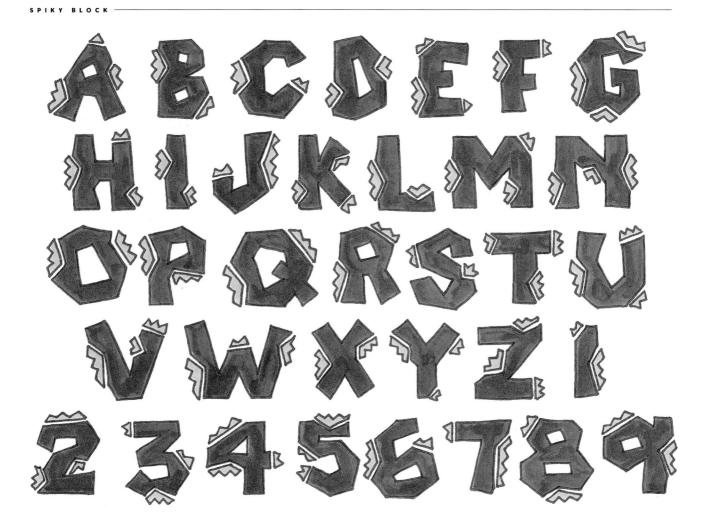

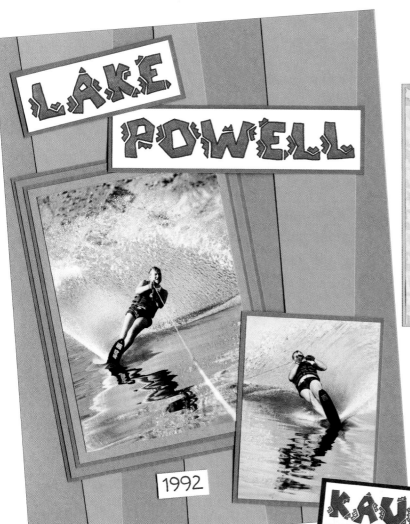

GOOD LUCK Black outline: Micron 08, Sakura. Pencils: Prismacolor, PC914 Cream and PC1034 Goldenrod, Sanford. Paper: Colors by Design.

LAKE POWELL Black outline: Micron 08, Sakura. Pencils: Prismacolor, PC941 Light Umber and PC943 Burnt Ochre, Sanford. Fun tip: Background created with unevenly cut strips of green placed on background cardstock.

KAULIN'S LAST DAY OF SCHOOL Black outline: Micron 08, Sakura. Pencil: Prismacolor, PC902 Ultramarine, Sanford. Paper: Paper Patch. Star punch: Family Treasures.

ALPHABET • BLOCK STRUCTURE Black outline: Micron 05, Sakura. Red pen: ZIG Scroll & Brush, EK Success. Yellow pen: ZIG Writer (Summer Sun), EK Success.

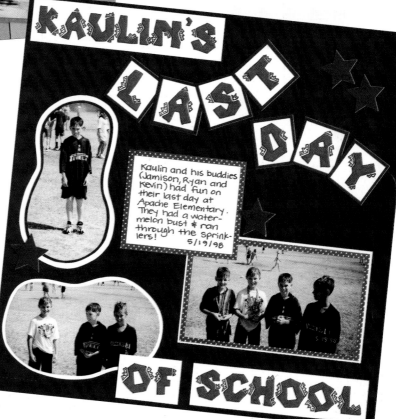

Kaulin and his buddies (Jamison, Ryan and Kevin) had fun on their last day at Apache Elementary. They had a watermelon bust & ran through the sprinklers! 5/19/98

Strips

ive, six, pick up sticks! Like the familiar childhood game, the Strips alphabet layers thin pieces of cardstock or decorative paper to create multicolored letters.

Begin by assembling a few sheets of cardstock in assorted colors. For a particularly funky touch, also gather up leftover scraps and bits of patterned papers, such as floral- or plaid-printed gift wrap ("Yard Sale"). Note that such papers work best with relatively wide letters, which allow enough space to showcase the pattern.

Cut the paper into rectangles of various lengths, but, of roughly the same width (for consistency). If necessary, use a ruler to mark guides on the underside of the paper—these pencil lines won't show once they're glued, face down, to the page.

Using the sample alphabet as a guide, layer the strips into letter shapes, then glue them in place using a fine-point glue pen such as the ZIG two-way glue or the Sailor 2 in 1 glue pen. For variety, glue the letters on boxes cut out from cardstock ("Turkey Day"), or outline the letters with a fine-point pen ("Yard Sale").

TURKEY DAY Blue pen: ZIG Writer (Navy), EK Success. Paper: Northern Spy.

THAT WAS THEN, THIS IS NOW
Blue pen: ZIG Writer, EK Success.

YARD SALE Papers: Paper Patch and Keeping Memories Alive. Black outline: Micron 03, Sakura.

ALPHABET • UNIQUE Strips of cardstock in various shades of blue.

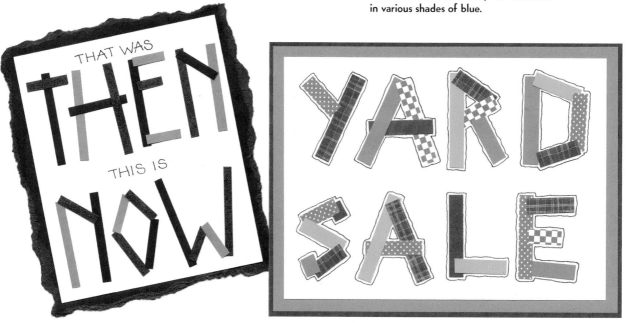

A B C D E
F G H I J
K L M N O
P Q R S T
U V W X Y
Z 1 2 3 4
5 6 7 8 9

SEASONS
alphabets

Winter, spring, summer, fall: When the seasons change, turn to the alphabet that best personifies Mother Nature's mood. Fourth of July picnic photos? Try Stars & Stripes, with its bright red and vivid blue rectangles. Bountiful harvest or masquerade ball? Consider the curly vines and plump gourds of Pumpkin Patch. Mother's Day? Send a card with Flower Power. Seasons alphabets can also express certain states of mind: Who cares if it's cold outside when you've got Sunshine to keep you warm? Best of all, many of these alphabets invite color—the abundant blossoms of Tulips, for example, allow you to paint your title in a rainbow palette.

Flower Garden

Blossoms are blooming in the Flower Garden, a spring-and-summer alphabet unique for its profusion of flowers and blades of grass. Before adding these defining decorative elements to your word or title, begin by penciling out the broad letters, basing their shape on the sample alphabet and allowing enough room to add the thick color blocks. To make each thick space, draw a parallel line on either side of the original, close off the top and bottom of the newly created section, then erase the original center line. Remember that in the case of circular letters such as "G," the thick space is formed like a crescent moon within the original curve.

At the base of each thick space, sketch a small cluster of grass, and erase any remnants of the original outline so that the bottom of each letter appears to be covered by the grass cluster. And notice that the grass sprouts out beyond the borders of the letters. Extend two or three curvy stems from the patch of grass, leaving room to add a flower blossom on the end of each: Allow these, too, to pop outside the letter's outline. To finish each letter, add an occasional curly serif or extra

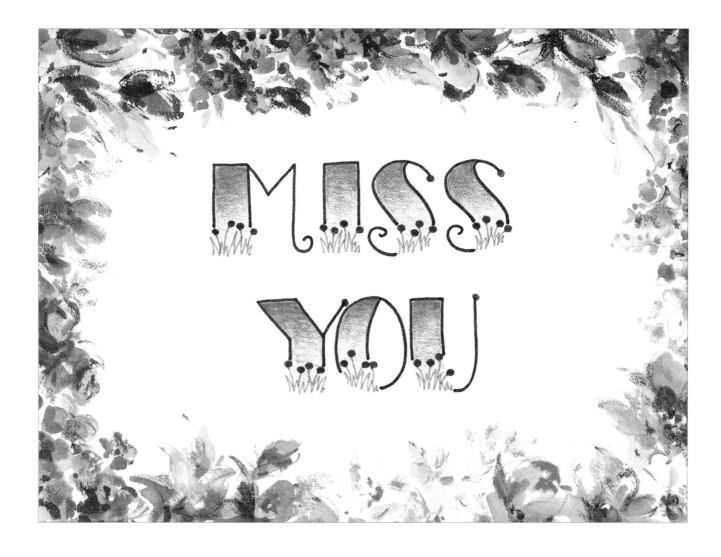

blossom to the ends of the simple, straight lines: Both are featured on the right-hand stem of "H."

When outlining the finished letters in ink, begin with the blades of grass, followed by the flower stems—save space for the blossoms, which you'll color later—then the rest of the letter. Blossoms can be created a number of different ways: Use different colors and sketch five short, thin petals, as shown in the sample alphabet, or draw a solid dot of color, as seen in "Miss You." "Just Because" mimics the assorted flowers in the photos. Fill in the letters' thick spaces with colored pencils, using a darker color at top and fading to a lighter shade as you move toward the blades of grass.

David gave this beautiful boquet to me in March 1999..."Just Because".

He has surprised me with flowers on so many special occasions since we've been together. But my favorite times were the "Just-Because" occasions ☺.

MISS YOU Black outline: Micron 08, Sanford. Pens: ZIG Writers (Aubergine, Evergreen, and Hot Pink), EK Success. Blue pencil: Prismacolor, PC 1022 Mediterranean Blue, Sanford. Paper: Rainbow World by Royal Stationery.

EMILY Pens: ZIG Writers (Black, Evergreen, and Red), EK Success. Flower punch: Family Treasures. Paper: The Robins Nest.

JUST BECAUSE Pens: ZIG Writers (Hunter Green, Red, Apricot, and Orchid), EK Success. Pencil: Prismacolor, PC 1005 Limepeel, Sanford. Laser cut window: Penny Black. Fun tip: "Pulled up" blinds effect achieved by threading string through the blinds' tiny holes.

ALPHABET • FILL-IN STRUCTURE Pens: ZIG Writers (Evergreen and Aubergine), EK Success. Pencil: Prismacolor, PC 1005 Limepeel, Sanford.

Aa Bb Cc Dd
Ee Ff Gg Hh
Ii Jj Kk Ll
Mm Nn Oo Pp
Qq Rr Ss Tt
Uu Vv Ww
Xx Yy Zz 1 2
3 4 5 6 7 8 9

Pumpkin Patch

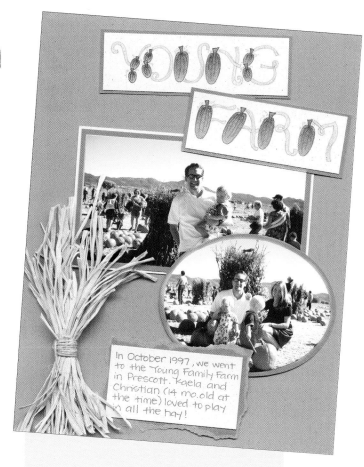

Even Linus would love the bumper crop of pumpkins growing from each letter in the Pumpkin Patch, an alphabet that celebrates the spirit of the harvest, from homecoming to Halloween.

Pumpkin Patch letters are formed from curly, vinelike lines just thick enough to hold some color. Begin by sketching the skeleton of each letter in pencil and then making your straight lines curly. For most uppercase letters, one tall, skinny pumpkin replaces the left-hand stem. Form these pumpkins by drawing an oblong oval and corking it on top with a rough triangular stem. Circular uppercase letters take two smaller, rounder pumpkins.

When outlining in ink, begin with a dark color for the pumpkin—brown, black, or deep orange. Section the interior of the pumpkin with ridges of varying lengths extending from the stem, and, in green, add a few tightly coiled tendrils. Black out eyes, nose, and mouth to make a jack-o'-lantern ("Trick or Treat"). Then outline the rest of the letter in either black or dark green. Color in the pumpkin, its stem, and the vinelike lines with lighter shades, preferably in chalk or pencil for a warm, autumnal look.

YOUNG FARM Pens: ZIG Writers (Coffee, Kiwi, and Brown), EK Success. Pencils: Memory Pencils, EK Success. Fun tip: Tie a small bunch of raffia together with string to re-create the haystacks in the pictures.

HALLOWEEN PARTY Brown pen: ZIG Writer (Coffee), EK Success. Pencils: Memory Pencils, EK Success. Vellum: Paper Cuts. Font: CK Script, "Best of Creative Lettering" CD, Creating Keepsakes. Paper: Scrapbook Adventures.

TRICK OR TREAT Black: ZIG Writer, EK Success. Pens: Marvy Le Plume, No. 96 Jungle Green and No. 54 Burnt Umber. Pencils: Prismacolor, PC908 Dark Green, PC946 Dark Brown, and PC1032 Pumpkin Orange, Sanford. Paper: Colors by Design. Candy corn stickers: Frances Meyer. Fun tip: Thin wisps of green cardstock near the stems were cut extremely thin with a paper cutter and they curled on their own.

ALPHABET • CURLY STRUCTURE Pens: Marvy Le Plume, No. 96 Jungle Green and No. 54 Burnt Umber. Pencils: Prismacolor, PC946 Dark Brown and PC908 Dark Green, Sanford. Chalk: Craf-T Products (Orange).

Aa Bb Cc Dd
Ee Ff Gg Hh
Ii Jj Kk Ll
Mm Nn Oo Pp
Qq Rr Ss Tt
Uu Vv Ww
Xx Yy Zz 1 2
3 4 5 6 7 8 9

Winter

Well, the weather outside is frightful, but the Winter alphabet will bring a smile to the face of the frostiest snowman. Keep the lines of Winter letters slightly shaky, as if they're shivering.

Pencil the frame of each letter and add the thick section by drawing a line on either side of the left-hand stem. Both lines should curve in toward the center, and flair out slightly at top and bottom. Close the bottom of each thick section with a wavy serif that extends just beyond the borders, and add curly serifs. For circular letters, the thick section is formed by a single line shaped like a crescent moon.

Cap the top of each thick section with a soft, rounded lump of snow. Vary the shape of the snow lumps from letter to letter. Outline the letters in ink, beginning with the snow lumps, followed by the thick sections and the single, shaky lines with their curly serifs. Erase leftover pencil marks. In the "Sledding" example, because the paper is buff colored, an opaque white pen keeps the snowcaps pure. Use colored pencils, chalks, or pens to fill in the rest.

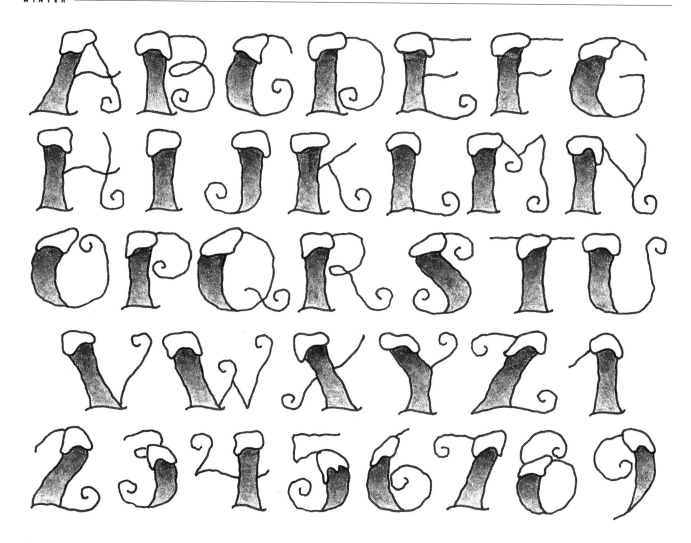

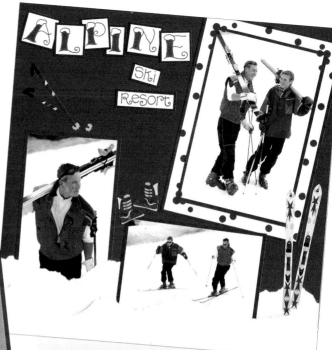

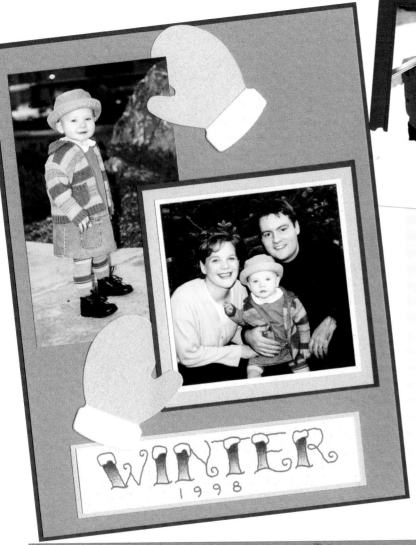

WINTER
1998

ALPINE SKI RESORT Black pen: Micron 08, Sakura. Red pen: ZIG Scroll & Brush, EK Success. Ski stickers: Stickopotamus. Pop dots: Pop-it-Up, Cut-it-Up. Circle punch: McGill.

WINTER 1998 Black outline: Micron 08, Sakura. Blue pencil: Prismacolor, PC901 Indigo Blue, Sanford. Mitten die cuts: Ellison.

SLEDDING Black pen: Micron 05, Sakura. Pencils: Prismacolor, PC908 Dark Green and PC941 Light Umber, Sanford. White Opaque pen: Sailor. Stickers: Debbie Mumm, Creative Imaginations.

ALPHABET • FILL-IN STRUCTURE Black outline: ZIG Writer, EK Success. Pencils: Prismacolor, PC902 Ultramarine and PC1040 Electric Blue, Sanford.

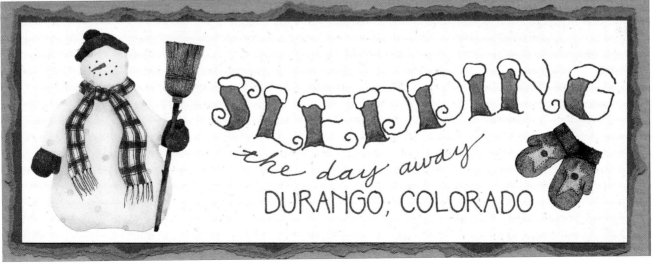

SLEDDING
the day away
DURANGO, COLORADO

Tulips

How do you say spring? With tulips! The blossoms of these beautiful flowers showcase an array of pastel colors.

Each letter in this alphabet gets one tulip: Uppercase letters feature a full stem; lowercase letters get just a flower head, plus a leaf or two. In penciling your letters, note the Curly Structure.

To make the tulips, begin with the stem: Draw a duplicate set of curvy lines, one on either side of the original line of the letter. Close this tube off at top and bottom, and erase the original center line. Think of the tulip blossoms as cracked eggshells: Sketch a rough half circle at the top of each stem, and spike the middle connecting line into three peaks for petals. Then add one or two teardrop-shaped leaves.

Trace stems, leaves, and letter lines in dark green or black ink. Outline the flower heads with a deeper shade of the same color you will use to fill them in. Erase pencil marks, and finish by coloring with pencil, chalk, or pen.

DEREK AND CAROLINA All pens: ZIG Writers (Burgundy, Hunter Green, and Spring Green), EK Success. Pencils: Prismacolor, PC921 Pale Vermillion and PC922 Poppy Red, Sanford. Tulip accents: Wallies, McCalls.

EASTER 1998 All pens: ZIG Writers (Evergreen and Apricot), EK Success. Pencils: Memory Pencils, EK Success. Paper: Northern Spy. Bow: Raffia Accents, Plaid.

SPRING All pens: Marvy Artist, No. 8 Violet and No. 11 Light Green. Pencils: Prismacolor, PC912 Apple Green and PC1008 Parma Violet, Sanford. Tulip die cuts: Ellison.

ALPHABET • CURLY STRUCTURE All pens: ZIG Writers (Rose, Burgundy, Spring Green, and Hunter Green), EK Success.

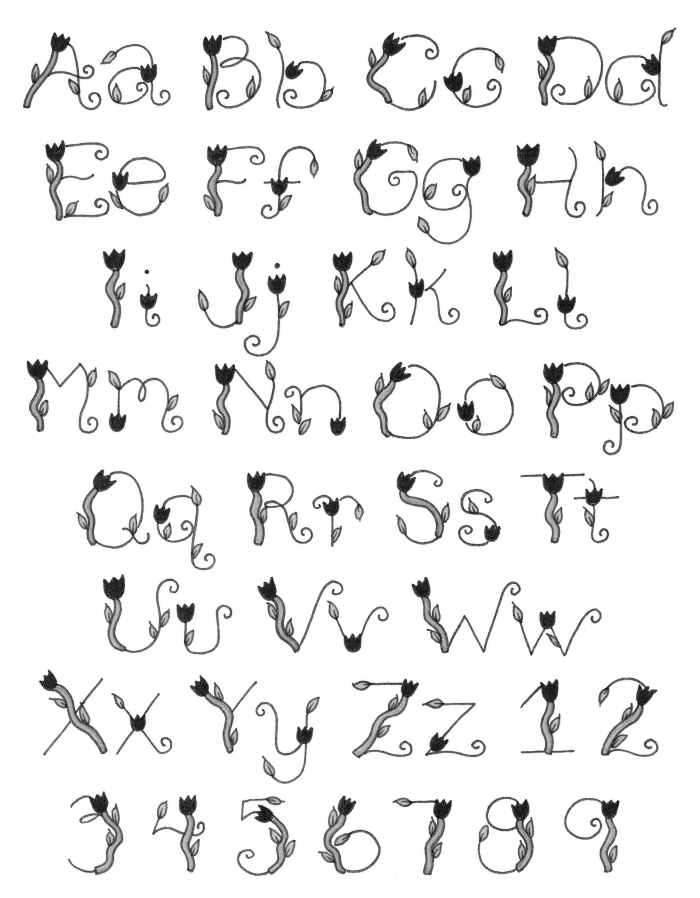

Sunshine

Gray skies are going to clear up when Sunshine hits the page. Keep the letters simple in this alphabet—the sun grabs all the attention—but experiment with different styles of lettering ("Florida"; "Spring Break"). The basic idea is to put each letter or word in its own box, with a sun peeking out from behind.

If placing each letter in its own box, use a stencil or ruler to trace a square on cardstock. Cut it out, and use this square as a template. The borders of the box can be slightly crooked, as shown in the sample alphabet, or perfectly straight. Punched circles of bright yellow cardstock are tucked behind each box to become small suns, while tiny triangles ("Spring Break") or thin strips ("Swim Lessons") make cheerful rays. Or the entire alphabet can be hand drawn: In "Florida," the outer rim of each disk is penciled a dark orange and blends into yellow toward the center. If you're feeling particularly cheeky, add a smiley face!

FLORIDA Black pen: Micron 05, Sakura. Orange pen: Marvy Artist, No. 7 Orange. Pencils: Prismacolor PC917 Sunburst Yellow and PC921 Pale Vermillion, Sanford.

SPRING BREAK Black and red pens: ZIG Writer, EK Success. Circle punch: Family Treasures. Triangle punch: McGill.

SWIM LESSONS Blue pen: ZIG Writer, EK Success. Paper: Frances Meyer. Circle punch: McGill. Circle cutter: Making Memories.

ALPHABET • PRINT STRUCTURE Black and orange pens: ZIG Writer, EK Success. Circle punch: McGill.

Stars & Stripes

As American as apple pie and the Fourth of July, the Stars & Stripes alphabet proudly displays its patriotic colors. Slim red and blue rectangles line the main vertical of each letter and are complemented by a sparkling array of stars.

Begin by penciling the wide, round, low-waisted letters of your word or title, then outlining in ink. Cut thin rectangular strips of red and blue cardstock, and, referring to the sample alphabet for placement, glue one on top of each letter. Note that circular letters such as "C" take two smaller rectangles, to accommodate the curve, and that lowercase letters take smaller rectangles. Finish with a flourish of punched stars, gluing one or two opposite each cardstock rectangle. You can also draw the entire letter ("Fireworks"), but the punched stars and cut out cardstock strips bring an interesting texture to your page.

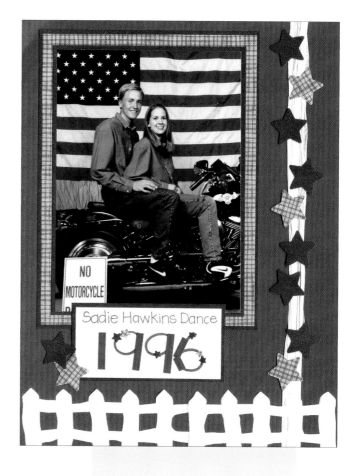

SADIE HAWKINS DANCE 1996
Blue pen: ZIG Writer (Navy), EK Success. Little star punch: Family Treasures. Large star punch: Marvy Uchida. Raffia: Raffia Accents, Plaid. Pattern paper: Keeping Memories Alive. Fence: Stamping Station.

FIREWORKS Black pen: Mircon 01 and 03, Sanford. Pencils: Prismacolor, PC906 Copenhagen Blue and PC937 Tuscan Red, Sanford. Font: CK Print, "Best of Creative Lettering" CD, Creating Keepsakes. Paper: Rainbow World by Royal Stationery. Fun tip: Stars and stripes are shaded lighter on the inside to darker on the outside.

FUN ON THE FOURTH Black pen: ZIG Writer, EK Success. Flag accent: Keeping Memories Alive. Stars punch: Family Treasures.

ALPHABET • SHAPES & MOTIFS STRUCTURE Black pen: ZIG Writer, EK Success. Star punch: Family Treasures.

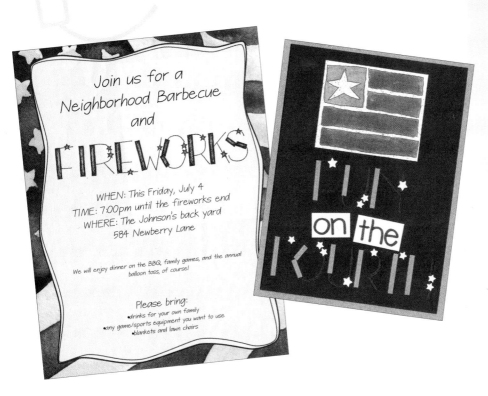

Aa Bb Cc Dd
Ee Ff Gg Hh
Ii Jj Kk Ll
Mm Nn Oo Pp
Qq Rr Ss Tt
Uu Vv Ww
Xx Yy Zz 1 2
3 4 5 6 7 8 9

Holly & Berries

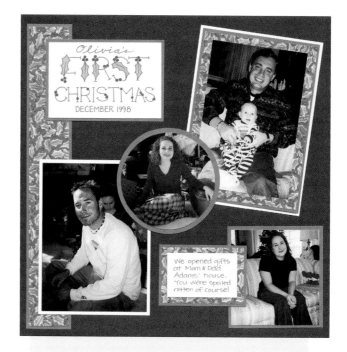

The Holly & Berries alphabet garnishes holiday pages with sprigs of evergreen and clusters of berries as red as Rudolph's nose. Each letter has one holly accent. The holly leaf curves along with the shape of the letter.

After penciling the letters, draw the leaves by running a reverse-scallop line on either side of the original, and connecting them in a point (see pp. 6 and 7). Fix a trio of berries to either the top or bottom of the leaf, and, perhaps, a couple of berries elsewhere. Erase excess pencil marks. (For a realistic effect, only partially erase the vein of the leaf.) Add small, flat serifs to the ends of lines.

Outline in black or dark green ink, beginning with the berries. Maintain a red and green scheme. (*Alphabet idea courtesy of Brooke McLay.*)

OLIVIA'S FIRST CHRISTMAS All pens: ZIG Writers (Red, Hunter Green, and Kiwi), EK Success. Paper: Colors by Design. Circle cutter: Making Memories.

HAPPY BIRTHDAY TO JESUS Black pen: Micron 08, Sanford. Green pen: ZIG Writer (Hunter Green), EK Success. Red pen: Marvy Le Plume, No. 28 English Red. Pencils: Prismacolor, PC911 Olive Green and PC937 Tuscan Red, Sanford. Mittens: Wimpole Street Creations.

HAPPY HOLIDAYS Black pen: Micron 08, Sanford. Green pen: ZIG Writer (Hunter Green), EK Success. Red pen: Marvy Le Plume, No. 28 English Red. Pencils: Prismacolor, PC911 Olive Green and PC924 Crimson Red, Sanford.

ALPHABET • SHAPES & MOTIFS STRUCTURE Black pen: Micron 08, Sanford. Green pen: ZIG Writer (Hunter Green), EK Success. Red pen: Marvy Le Plume, No. 28 English Red. Pencils: Prismacolor, PC911 Olive Green and PC924 Crimson Red, Sanford.

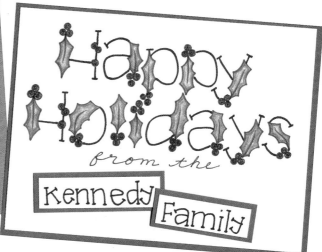

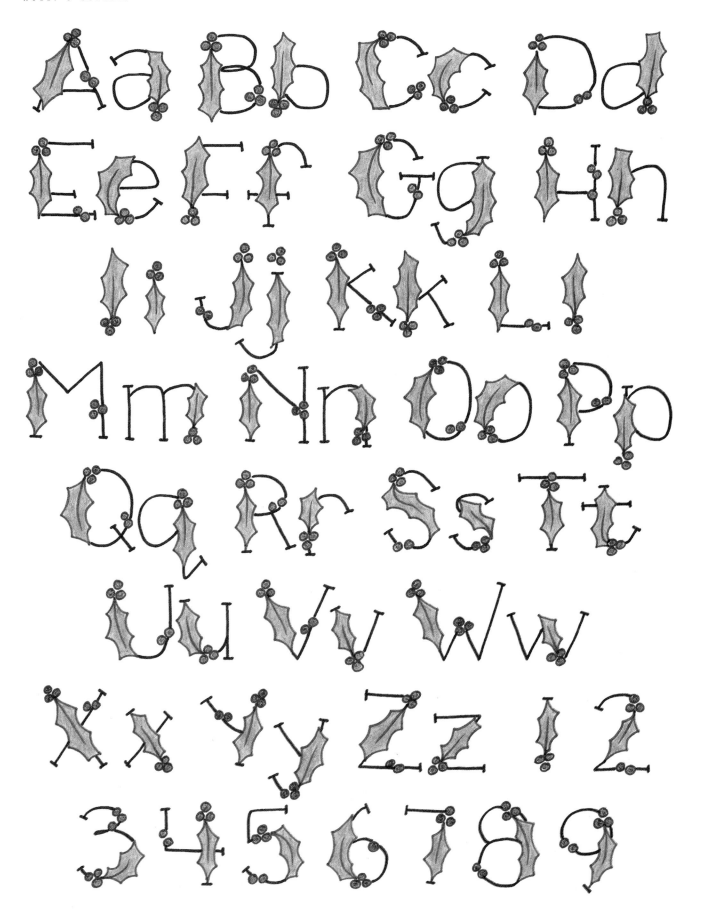

Flower Power

Flower Power packs a punch with a bunch of bright blossoms on vinelike lines. As seen in the sample, the letters of this cheerful alphabet are made from loose, fluid lines that often curl at the ends. Lines don't have to be green, although it's the natural choice: Other dark colors ("Friends Forever") work equally well.

Draw your word or title in pencil first: The letters are easy enough to freehand, but you'll want to experiment with the number and place-ment of flowers before committing them to ink. You can outline the daisies with a fine-point pen ("Good Hair Day"), or use a brush pen to make each blossom a touch more lush. Practice the following technique on scrap paper first: Touch the point of the brush to the paper, then, without sliding the pen, push the tip down, bringing the thicker part to the page. Lift up to view the result: One teardrop-shaped flower petal. Repeat this technique in a circular direction to create each flower blossom. After inking the flowers, outline the rest of the letter in pen.

FRIENDS FOREVER Brush pens: ZIG Scroll & Brush (Blue Jay, Pink, Spring Green, and Orange), EK Success. Purple pen: ZIG Writer (Orchid), EK Success.

CONGRATS ON BABY Red and pink brush pens: Micron Brush, Sakura. Red and pink pens: Micon 05, Sakura. Green pen: ZIG Writer (Spring Green), EK Success.

GOOD HAIR DAY Black pen: ZIG Writer, EK Success. White and yellow pens: ZIG Opaque Writer, EK Success. Daisey punch: Family Treasures. Hole punch: McGill. Paper: Provo Craft.

ALPHABET • CURLY STRUCTURE Purple and pink pens: Marvy Le Plume, No. 8 Violet and No. 9 Pink. Green pen: Marvy Artist, No. 101 Tropical.

Aa Bb Cc Dd
Ee Ff Gg Hh
Ii Jj Kk Ll
Mm Nn Oo Pp
Qq Rr Ss Tt
Uu Vv Ww
Xx Yy Zz 1 2
3 4 5 6 7 8 9

THEMES
alphabets

A theme of *The Art of Creative Lettering*

is creativity, and the alphabets in this chapter

make terrific inspirational springboards.

Crayons, Pencils, Rocket Ships, and Balloons

employ the Shapes & Motifs Structure

to create their namesake shapes. Happy Kids

takes simple lettering and dresses it up with

small illustrations. It's easy to customize

lettering to match the theme of your individ-

ual project. Instead of the smiling faces

on Happy Kids, try tiny star or heart stickers.

Why not holiday ornaments instead of Sports

Balls in that alphabet's round spaces?

Set your imagination loose, and soon you'll

have alphabets all your own.

Pencils

Reading, 'riting, 'rithmetic: The fundamental things apply in Pencils, an eraser-headed, pointy-ended alphabet in which each uppercase letter is founded on everyone's favorite stubby little lead utensil. Add an apple for the teacher, and it's off to school.

Pencil the simple lines of your word or phrase, then add the thin spaces for color, referring to the sample alphabet for placement. The pencil shape is made of a rectangle finished on one end with a triangular point—although, in the case of circular letters, the pencil shape curves to follow the rounded lines. Leaving space on one end for the triangular point, draw a set of parallel lines, one on either side of the original, close off at top and bottom, then erase the center line.

Next add the triangle. It doesn't matter which way the pencil points—for variety, alternate top to bottom in your title. Erase the base line that is shared by the triangle and the rectangle, and any other remnants of the original line that would interfere with the pencil shape.

When outlining in ink, begin with the pencil shape. (If it helps, use an actual pencil as a reference.) Add a black tip at the very end of the triangle to mark the lead point. Draw a jagged line where the triangle broadens into the rectangle to indicate the place where the pencil is shaved. And within the rectangle shape, include a few vertical lines, for the sides of the pencil, and a few horizontal lines, for the metal wrap that holds the eraser in place. Outline the rest of the letter.

The classic #2 pencil is a warm orange-yellow, but pencils come in all sorts of colors, so use shades that complement your project's scheme ("Pen Pals"). And if you are using other accents, such as stickers, be sure to take them into account when lettering. In "First Day of School," the pencil letters are long and simple to match the pencil stickers. For the same reason, the pencil letters in "Back to Class" are more elaborately detailed.

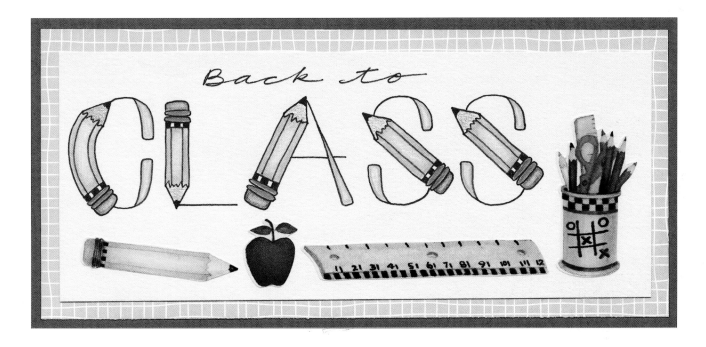

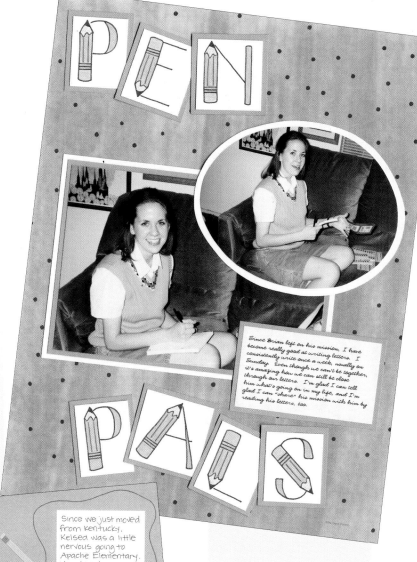

BACK TO CLASS Black pen: Micron 02, Sakura. Pencils: Memory Pencils, EK Success. Stickers: Debbie Mumm, Creative Imaginations. Yellow plaid paper: MPR Paperbilities II.

PEN PALS Black pen: Micron 05, Sakura. Pencils: Prismacolor, PC945 Sienna Brown, PC1019 Rosy Beige, PC1020 Celadon Green, Sanford. Silver pen: Gelly Roll, Sakura. Paper: Paper Patch. Font: CK Script, "The Best of Creative Lettering," CD Creating Keepsakes.

Since we just moved from Kentucky, Kelsea was a little nervous going to Apache Elementary. Her teacher was Mrs. Ferguson.

FIRST DAY OF SCHOOL
Black pens: Micron 02, 05, Sakura. Pens: ZIG Writers (Summer Sun and Candy Pink), EK Success. Brown pencil: Prismacolor, PC945 Sienna Brown, Sanford. Pencil stickers: Stickopotamus.

ALPHABET • SHAPES & MOTIFS STRUCTURE
Black outline: ZIG Writer, EK Success and Micron 005, Sakura. Pencils: Prismacolor, PC942 Yellow Ochre, PC943 Burnt Ochre, and PC945 Sienna Brown, Sanford. Silver pen: Gelly Roll, Sakura.

Aa Bb Cc Dd
Ee Ff Gg Hh
Ii Jj Kk Ll
Mm Nn Oo Pp
Qq Rr Ss Tt
Uu Vv Ww
Xx Yy Zz 12
3 4 5 6 7 8 9

Cracked

Mist hangs low over the lake. Sparrows sing to the approaching dawn. Alongside young saplings, oak elders stand proud and tall—their age betrayed by the cracks in their trunks.

Cracked is a rustic alphabet created by weathering basic block letters. Begin by penciling simple lines, then adding the thick spaces and erasing the original center lines. Then, in pencil, cut small, uneven notches into the block letters, and generally rough up the straight edges. Envision the coarse, split bark of a tree.

Outline in brown or black ink. Chalk blurred just beyond the borders of each letter and colored pencils work well. "Sedona" features two shades blended.

SEDONA Brown pen: ZIG Writer (Chocolate), EK Success. Pencils: Prismacolor, PC944 Terra Cotta and PC1032 Pumpkin Orange, Sanford. Thread: DMC. Hole punch: McGill. Fun tip: The two ripped pieces of paper were literally stitched together and a different tan cardstock was adhered behind the open space between.

NEVELDA Black pen: Micron 02, 08. Pencil: Prismacolor, PC948 Sepia, Sanford. Blender: Prismacolor, Sanford. Paper: Keeping Memories Alive. Plum Clusters: Wallies, McCalls. Corners and frames: K & Co.

ALPHABET • BLOCK STRUCTURE Pen: ZIG Writer (Coffee), EK Success. Chalk: Craf-T Products (Brown).

Aa Bb Cc Dd
Ee Ff Gg Hh
Ii Jj Kk Ll
Mm Nn Oo Pp
Qq Rr Ss Tt
Uu Vv Ww
Xx Yy Zz 1 2
3 4 5 6 7 8 9

Crayons

A waxy rainbow brightens the giddy, kiddy alphabet called Crayons. Every uppercase letter comes with its own crayon; lowercase letters are written to mimic a child's charmingly crooked hand.

Pencil letters in wide, wavering lines. Then add the crayons (it doesn't matter which way the crayon points) by drawing a line on either side of the main vertical line. Close it off at top and bottom, and erase the center line. Add a blunt triangle for the point, keeping its base slightly less wide than the rectangle.

Outline in black and add a thin horizontal bar at the top and bottom. Color the triangular tip and the base and fill in the middle "label" with a lighter shade. Colored pencils work well, or try actual crayons: What they lack in precision, they make up for in enthusiasm!

ABC Black pen: Marvy Medallion 05. Pens: Marvy Artist, No. 2 Red, No. 11 Light Green, No. 75 Sky Blue. Pencils: Prismacolor, PC906 Copenhagen Blue, PC909 Grass Green, and PC924 Crimson Red, Sanford.

PRESCHOOL Black and red pens: ZIG Writers, EK Success. Pencil: Prismacolor, PC924 Crimson Red, Sanford. Crayon stickers: Frances Meyer. Paper: Bazzill Engraving Co.

ARTISTS AT WORK Black pen: Micron 02, Sakura. Pencil: Prismacolor, PC1025 Periwinkle, Sanford. Paper and crayon accents: Keeping Memories Alive. Fun tip: Make color copies of the original artwork and reduce the sizes to fit on the page.

ALPHABET • SHAPES & MOTIFS STRUCTURE
Black pen: ZIG Writer, EK Success. Pencils: Prismacolor, PC902 Ultramarine, PC909 Grass Green, PC921 Pale Vermillion, PC924 Crimson Red, and PC932 Violet, Sanford.

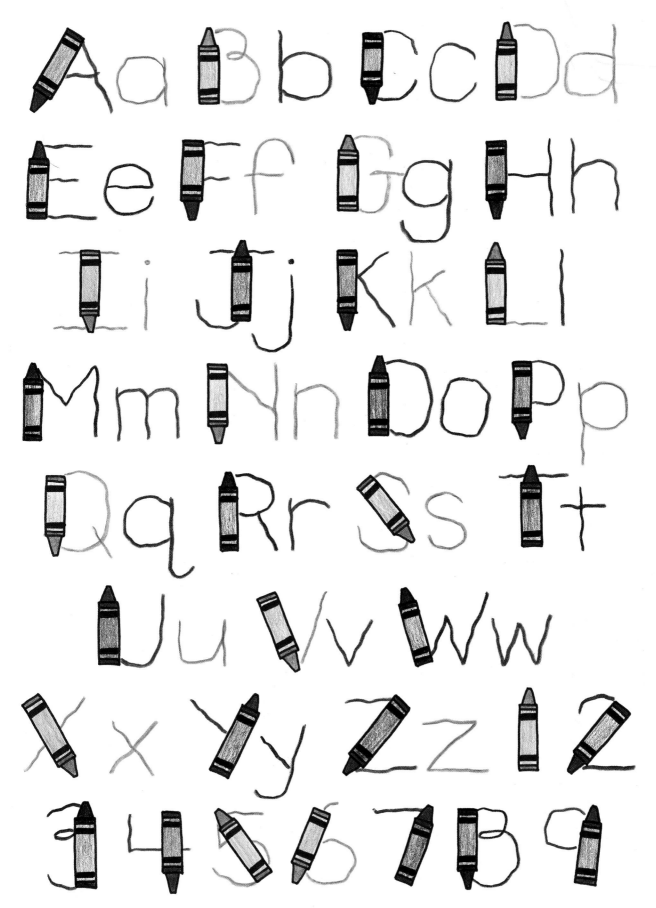

Balloons

U p, up, and away! Wouldn't you like to fly, somewhere way up high, with these beautiful Balloons? A happy alphabet full of hot air, Balloons consists of thick lines that hold down their inflated counterparts.

To begin, review the sample alphabet. Notice that the left-hand side of every letter (except diagonal letters such as "S" and "Z") is made from a curly-stringed balloon. Practice a few of these looped, curly lines on scrap paper.

ABCDEFG
HIJKLMN
OPQRSTU
VWXYZ12
3456789

Pencil your title, keeping letters round and waists low. Then, referring to the sample for placement, add the curly string, making sure to leave enough room for the balloon letter. Top each string with a tiny, rounded triangle, to represent the tie of the balloon, and a small, chubby version of the same letter. The top of the balloon should more or less line up with the height of the rest of the letter—if it floats any higher, it will break the form.

Using a pen of medium thickness, outline every part of the letter except the curly string and its balloon. Trace over the string and around the shape of the balloon with a finer-point pen. Then color in the balloons according to the occasion. For a fun variation, draw regular, round balloons on each letter ("Chandler").

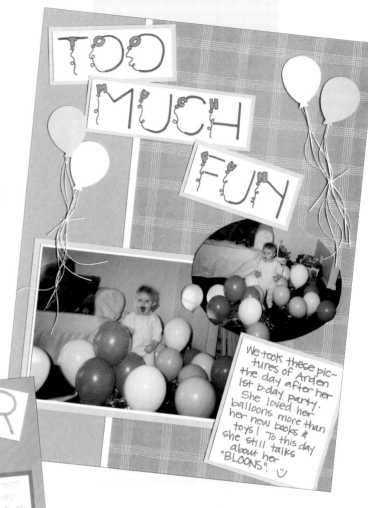

BIRTHDAY PARTY All pens: ZIG Writers (Black, Red, Orange, Green, Blue, Orchid), EK Success.

TOO MUCH FUN Pink pen: Marvy Artist, No. 9 Pink. Pencil: Prismacolor, PC929 Pink, Sanford. Balloon punch: Family Treasures. Paper: Stampin' Up! Fun tip: Glue very thinly cut strips of paper to the balloons and tie them together with another thin strip.

CHANDLER Blue pens: ZIG Writers (Light Blue and Bluebonnet), EK Success. Scissors: Fiskars (Bat Wings). Balloon sticker: Frances Meyer.

ALPHABET • SHAPES & MOTIFS STRUCTURE Black and red pens: ZIG Writer, EK Success.

Happy Kids

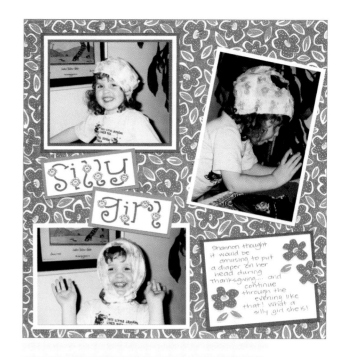

I n the Happy Kids alphabet, shiny, smiling faces play peek-a-boo, popping up on every letter like Jacks (and Jills) -in-the-box.

Begin by penciling the letter lines. Notice the little touches: "A" has a low waist, but on "B" it's quite high; "Z" has both flat and curly serifs. In general, uppercase letters are tall and thin, lowercase letters, short and wide. Next, add the faces by drawing a loose circle, and adding two dot eyes, a smile, hair—a crewcut, poufy pony-tails, Shirley Temple tendrils, whatever!

Outline the face in ink using a fine-point pen. Try thick and thin pens for the rest of the letter. Black lines help faces stand out. The faces don't have to be colored in ("Timothy"), but you can shade them with flesh-colored pencils. Hair can be different colors, too.

SILLY GIRL Black pen: Micron 01, Sakura. Pens: ZIG Writers (Red and Coffee), EK Success. Pencil: Prismacolor, PC939 Peach. Paper: Paper Adventures. Fun tip: To accent the journaling block, cut flowers and leaves from the paper (behind where the picture was going to go).

TIMOTHY Black pen: Micron 01, Sakura. Pens: ZIG Writers (Coffee and Denim), EK Success. Stickers: Me & My Big Ideas.

HAPPY BIRTHDAY CODY Brown pen: ZIG Writer (Coffee), EK Success. Brown ink: Serenade (Brown Shades), Tsukineko, Inc. Stamp: Judi-kins. Pencil: Prismacolor, PC945 Sienna Brown, Sanford.

ALPHABET • PRINT STRUCTURE Black pens: Micron 01, 05, Sakura. Pencils: Prismacolor, PC939 Peach, PC945 Sienna Brown, and PC946 Dark Brown, Sanford.

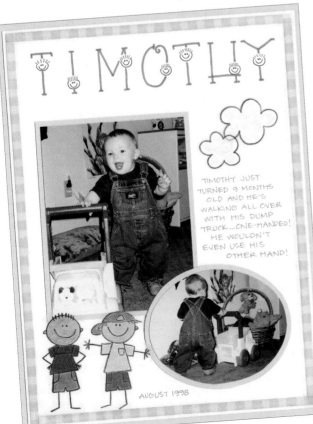

Aa Bb Cc Dd
Ee Ff Gg Hh
Ii Jj Kk Ll
Mm Nn Oo Pp
Qq Rr Ss Tt
Uu Vv Ww
Xx Yy Zz 1 2
3 4 5 6 7 8 9

Logs

Looks like ol' Abe Lincoln was here: A cabin supports each letter in Logs. The emphasis in this alphabet is on the box that houses the letter. Keep the lettering simple.

Begin by cutting out a square for each letter. Next, chop up your logs: Cut several strips (specifically, four per square) of brown cardstock or printed paper that simulates wood grain ("Five Months"). The strips should all be roughly the same size, and slightly longer than the width of the squares. Small boxes are best framed by simple, straight logs. Bigger blocks take logs with rough edges and rounded ends.

After cutting all the letter squares and accompanying logs, experiment with the placement on the page before gluing them down. For a jolt of energy, jumble the blocks. Glue down the squares, then add the logs: Place each one directly on top of its side of the square—not above it—so that the edges of the square are covered. Use a thin adhesive or fine-point glue pen to adhere the logs, and layer them for the overlapping effect. Finally, draw your letters inside each log cabin.

Coloring tip: For a rustic look, take a chalk applicator or chalk-dusted cotton swab and, after the logs are glued down, softly smear chalk on their inside edges. Leave the middle of the blocks blank (see "Camp").

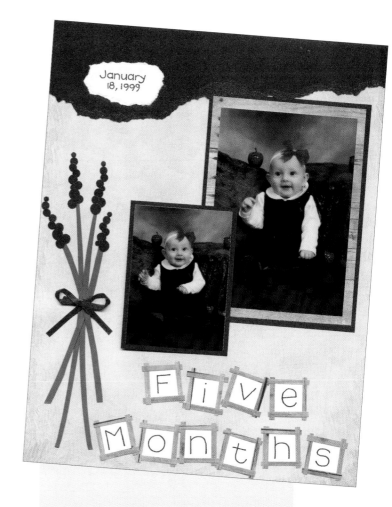

FIVE MONTHS Black pen: ZIG Writer, EK Success. Paper: The Boyds Collection Ltd., InterArt Distribution. Red ribbon: Offray. Wood paper: Paper Pizazz, Hot Off the Press. Circle punch: McGill. Fun tip: The log frames were cut from the wood paper. Also, green strips were hand cut and tied together with red ribbon.

CAMP Brown pen: ZIG Writer (Chocolate), EK Success. Chalk: Craf-T Products (Brown).

ALPHABET • BASIC LETTERING Pen: Marvy Artist, No. 54 Burnt Umber.

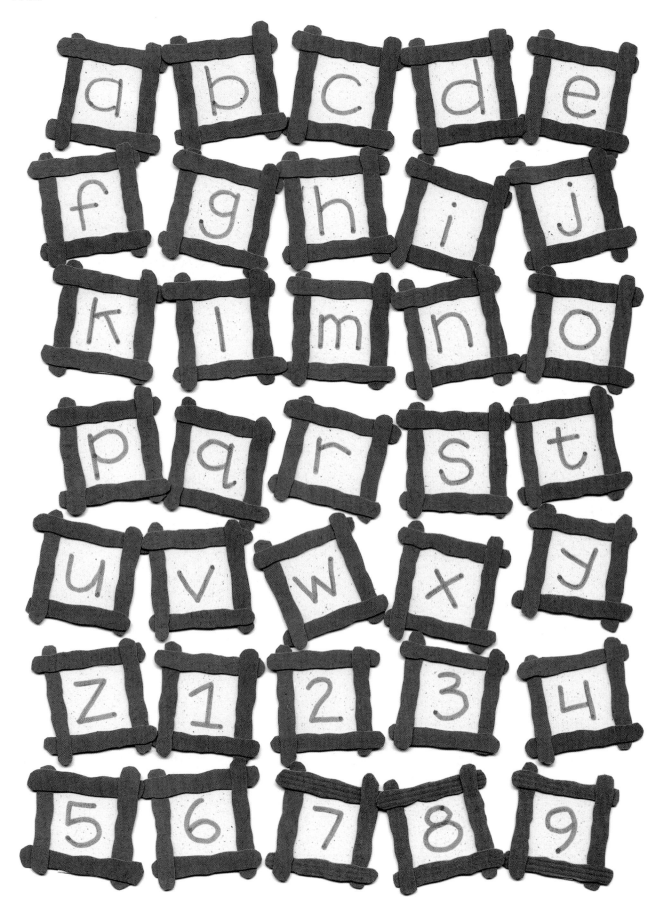

Quilt Squares

How to make an American quilt? All it takes is a few easy stitches—and scraps and squares sewn together into a colorful hodgepodge. The Quilt Squares font is as busy as a bee, so use it sparingly.

Begin by sketching the skeletal structure of the letters in pencil. Next, add squares one at a time on top of the original letter line, tilting and overlapping them. Stitch the squares together with a few sparse tick marks, and let some of them stick out into space. Notice that, on lowercase letters, some of these cross-stitches stand on their own. Erase any remnants of the original lines running through the squares.

Outline the letters with a fine-point pen. Then add solid colors, alternating several shades within the same letter. Bigger letters can hold an assortment of patterns—dots, checks, stripes—but break these up with solid-colored squares.

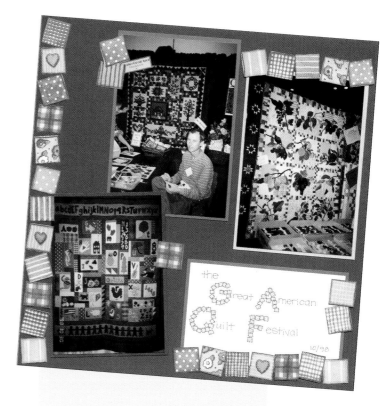

GREAT AMERICAN QUILT FESTIVAL Blue pen: ZIG Writer (Denim), EK Success. Brown pen: ZIG Millennium 005, EK Success. Yellow pencil: Memory Pencils, EK Success. Quilt squares: cut from Karen Foster paper.

THANK YOU Black pens: Micron 02, 08, Sakura. Pencils: Prismacolor, PC1029 Mahogany Red and PC1034 Goldenrod, Sanford. Paper: the Boyds Collection Ltd., InterArt Distribution. Buttons: Dress it Up. Thread: DMC.

ESTHER Black pen: Micron 05, Sakura. Pens: ZIG Writers (Sagebrush and Plum Mist), EK Success.

ALPHABET • PRINT STRUCTURE Black pens: Micron 005, 02, Sakura. Pens: ZIG Writers (Denim, Kiwi, Aubergine, and Coffee), EK Success.

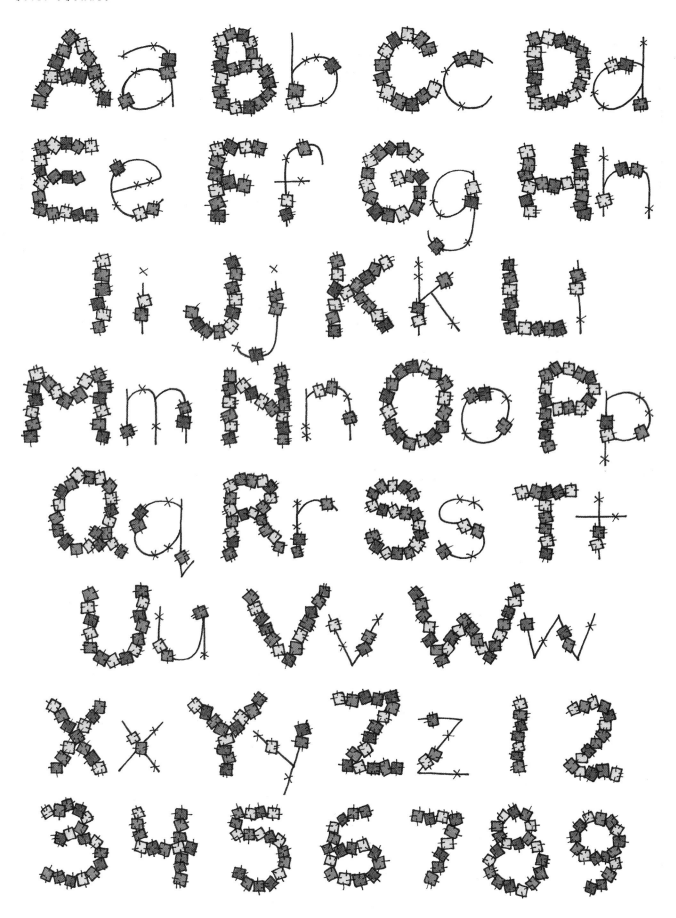

Rocket Ships

Three, two, one . . . countdown to lift off! Every letter in Rocket Ships is about to blast off from its launching pad.

A rectangle topped with a triangle forms the basic shape of the rocket. A smaller rectangle, running horizontally at the base, acts as the engine, and the sides of the rocket are flanked with wings. If you find it challenging to draw the wings freehand, imagine them as a much smaller version of the same rectangle-triangle rocket shape, cut straight down the middle, in

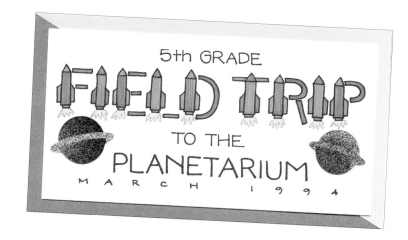

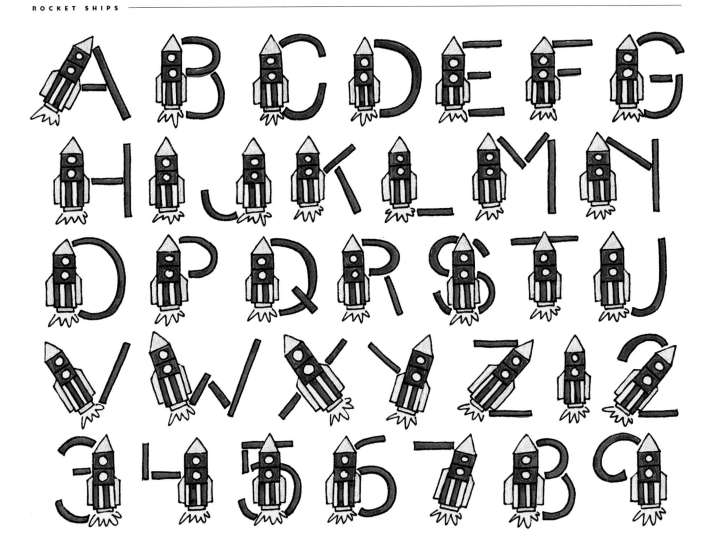

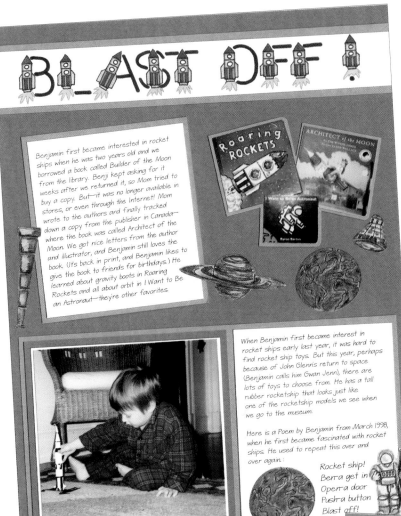

BLAST OFF

Benjamin first became interested in rocket ships when he was two years old and we borrowed a book called Builder of the Moon from the library. Benji kept asking for it weeks after we returned it, so Mom tried to buy a copy. But—it was no longer available in stores, or even through the Internet! Mom wrote to the authors and finally tracked down a copy from the publisher in Canada—where the book was called Architect of the Moon. We got nice letters from the author and illustrator, and Benjamin still loves the book. (It's back in print, and Benjamin likes to give the book to friends for birthdays.) He learned about gravity boots in Roaring Rockets and all about orbit in I Want to Be an Astronaut—they're other favorites.

When Benjamin first became interest in rocket ships early last year, it was hard to find rocket ship toys. But this year, perhaps because of John Glenn's return to space (Benjamin calls him Gwan Jenn), there are lots of toys to choose from. He has a tall rubber rocketship that looks just like one of the rocketship models we see when we go to the museum.

Here is a Poem by Benjamin from March 1998, when he first became fascinated with rocket ships. He used to repeat this over and over again:

Rocket ship!
Berra get in
Open a door
Push a button
Blast off!

FIELD TRIP Black pens: Micron 05, 08, Sakura. Pens: ZIG Writers (Yellow, Orange, Blue Jay, Spring Green), EK Success. Stickers: Stickopotamus.

BLAST OFF Thin black pen: Mircon 03, Sakura. Pens: ZIG Writers (Black, Orange, Summer Sun, Navy, Blue Jay), EK Success. Silver pen: Gelly Roll, Sakura. Font: CKPrint, "Best of Creative Lettering," CD Creating Keepsakes. Stickers: DMD Industries.

AIR AND SPACE MUSEUM Black pens: Micron 05 and 08, Sakura. Pencils: Prismacolor, PC941 Light Umber, PC942 Yellow Ochre, PC945 Sienna Brown, and PC936 Slate Gray, Sanford.

ALPHABET • SHAPES & MOTIFS STRUCTURE Black outline: Micron 02, Sakura. Silver pen: Gelly Roll, Sakura. Pens: ZIG Writers (Red, Blue, Yellow), EK Success.

half. Two small circles for windows, a few decorative stripes, and scribbled sparks underneath the engine will launch your celestial vessel on its voyage into space.

After writing your title in pencil, add the thin block lines and rocket ship shape. Erase any excess marks and outline the letters in black or deep blue. Metallic pens add an extra-terrestrial touch, mimicking the shiny steel casing of real es. Bright reds, whites, and blues work o—perfect for a page commemorating a the planetarium or space museum.

Tall Trees

Populate your pages with a forest of fir, a plethora of pine, a sprinkling of spruce. The Tall Trees alphabet brings a touch of nature to your titles, and is quite easy to draw.

Each letter holds one skinny, simply shaped tree, roughly drafted for a rustic look. Basically, each tree consists of a narrow triangle on top of a small, square stump. The rest of the letter is formed from thin, shaky lines.

After penciling your letters and drawing the trees, erase excess marks and outline the letters in dark ink—black, brown, or deep green. The interior of the triangular tree should be colored with green pencil, pen, or chalk. For winter, cap the boughs with dollops of snow. Experiment with the shape: "Christmas Tree Shopping" divides its triangles into three sections. For a textured feel, cut the trees out of cardstock.

MERRY CHRISTMAS Pens: ZIG Writers (Evergreen and Coffee), EK Success. White pen: ZIG Opaque Writer, EK Success. Pencils: Prismacolor, PC911 Olive Green and PC945 Sienna Brown, Sanford. Natural paper: Craf-T Pedlars. Punch: Family Treasures. Circle punch: McGill.

DADDY AND ME Green pen: ZIG Writer (Evergreen), EK Success. Embossing template: Lasting Impressions. Font: CK Print, "Best of Creative Lettering," CD Creating Keepsakes. Fun tip: After embossing the trees, silhouette and then place on background.

CHRISTMAS TREE SHOPPING Black pen: Micron 08, Sakura. Yellow pen: ZIG Writer, EK Success. Pencils: Memory Pencils, EK Success. Tree accents: cut from Stamping Station paper.

ALPHABET • SHAPES & MOTIFS STRUCTURE Pens: ZIG Writers (Evergreen and Coffee), EK Success. Pencils: Prismacolor, PC911 Olive Green and PC945 Sienna Brown, Sanford. Blender: Prismacolor, Sanford.

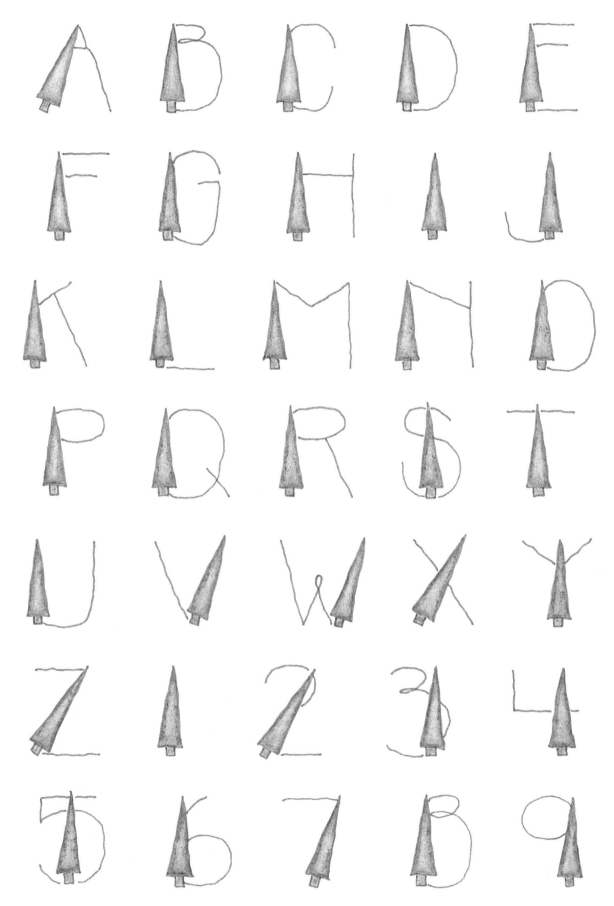

Sports Balls

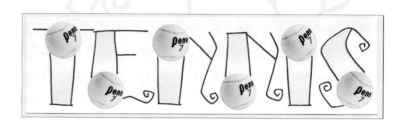

Batter up! Tennis anyone? Fore! There's no dodging balls here. Baseball, soccer, basketball, tennis, bowling, golf, billiards—mixed together or in a single-sport section, all types of games can be highlighted with this bouncing alphabet.

Before adding the balls to your word or phrase, draw the basic shape of the letters in pencil. On most letters, the thick space is formed by drawing two lines, one on either side of the original, and gradually fanning them outward at top or bottom. Circular letters take on an angular look because the line you draw

inside the thick space is notched in the middle like a boomerang.

You can hand draw the balls, make them from a hole puncher, or use small stickers ("Tennis"). If using stickers or gluing punched holes, add them after you've penciled and outlined the rest of the letter, so that you don't accidentally write over them in ink. When

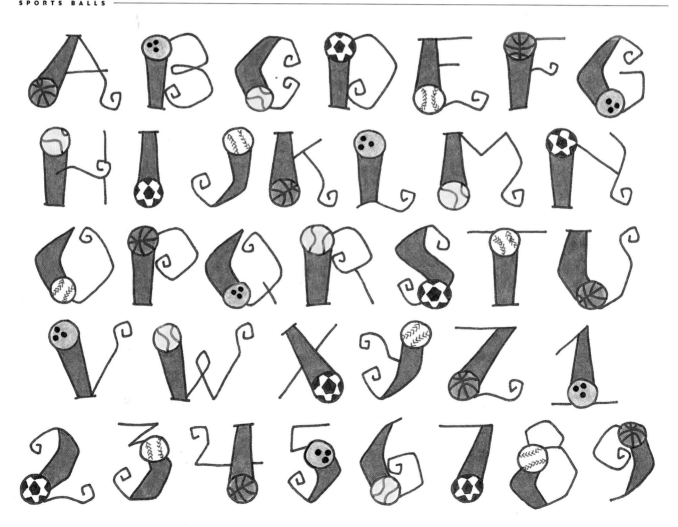

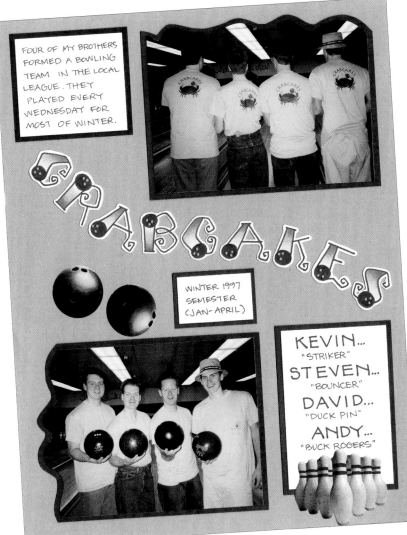

FOUR OF MY BROTHERS FORMED A BOWLING TEAM IN THE LOCAL LEAGUE. THEY PLAYED EVERY WEDNESDAY FOR MOST OF WINTER.

WINTER 1997 SEMESTER (JAN-APRIL)

KEVIN...
"STRIKER"
STEVEN...
"BOUNCER"
DAVID...
"DUCK PIN"
ANDY...
"BUCK ROGERS"

CRABCAKES Black pens: Micron 02, 08, Sakura. Blue pencil: Prismacolor, PC1022 Mediterranean Blue, Sanford. Stickers: Frances Meyer. Hole punch: McGill. Fun tip: Silhouette around each letter after drawing it on white paper and also punch tiny holes in the bowling balls of the letters.

TENNIS Black pen: Micron 08, Sakura. Pencil: Prismacolor, PC1004 Chartreuse, Sanford. Stickers: Paper House Productions.

LITTLE LEAGUE Black pens: Micron 005, 05, Sakura. Red pen: Marvy Le Plume, No. 2 Red. Thin red pen: Marvy Medallion 005. Large baseball: Frances Meyer. Small baseballs: Paper House Productions.

ALPHABET • ANGULAR STRUCTURE Black outline: ZIG Writer, EK Success. Pencils: Prismacolor, PC906 Copenhagen Blue, PC921 Pale Vermillion, PC1004 Yellow Chartreuse, and PC1052 Warm Grey 30%, Sanford. Red pen in baseballs: ZIG Millennium 01, EK Success.

drawing the balls, refer to the sample alphabet for placement, and add each circle directly on top of the rest of the letter. Then erase any overlapping lines, so that the ball is blank. Outline the final shape of the letter with dark-colored ink, and color in the thick spaces with pen or pencil. The focus should be on the sports balls, so only use a pattern if it enhances the effect—thin pinstripes on a baseball page, for example.

To decorate the different types of balls: A bowling ball needs three finger holes; a baseball is stitched with two lines of "V"s; a soccer ball alternates black pentagons and white hexagons; and a basketball looks something like a globe, with an equator, a meridian, and north and south poles.

1997

1996

Twigs

A bramble of branches and spindly sticks wrap themselves around every letter in the Twigs alphabet, creating countrified letters that at any moment might sprout a leaf or two. Camping, hunting, hiking—Twigs says it all.

Begin by penciling your word or phrase in skinny block letters, then transform them into natural-looking twigs by rounding the edges, twisting the lines in and out, and adding knots, knobs, and notches. Because twigs are pliant, bend them around the curves of circular letters, and allow their ends to overlap. Erase any remnants of the original straight lines.

To keep the woodsy feel, outline in brown—not black—ink. Give the twigs woodgrain accents by adding fine, dark brown lines and swirls ("East Willow Camp"). Then shade the twigs with a lighter brown, using chalks or colored pencils for a soft look. If space permits, sketch a few green leaves.

OUR TREEHOUSE Brown pen: ZIG Millennium 05, EK Success. Chalk: Craf-T Products (Dark Brown). Hole punch: McGill. Other: raffia. Fun tip: After chalking in letters, smear the color with a tissue across the entire title block.

EAST WILLOW CAMP Brown pen: ZIG Writer (Chocolate), EK Success. Pencil: Prismacolor, PC946 Dark Brown, Sanford. Green papers: Bamboo Weave and Crinkle Peat, Solum World.

BROWNING RANCH Brown pen: ZIG Writer (Chocolate), EK Success. Pencil: Prismacolor, PC945 Sienna Brown, Sanford. Brown mulberry paper: Personal Stamp Exchange.

ALPHABET • BLOCK STRUCTURE Brown outline: ZIG Millennium 03, EK Success. Pencil: Prismacolor, PC945 Sienna Brown, Sanford.

THE PHOTO AT THE TOP IS ROLLIN ON BUTCH (THE HORSE) AT LITTLE CREEK RIDGE. THIS WAS AT THE HEAD OF THE CUNNINGHAM TRAIL.

JOSH SHOT HIS FIRST PHEASANT ON THE GUYS' TRIP TO MORGAN, UTAH. BROWNING RANCH WAS VERY BEAUTIFUL AND FUN WAS HAD BY ALL. THIS WAS IN NOVEMBER (THANKSGIVING TIME) 1989.

Aa Bb Cc Dd
Ee Ff Gg Hh
Ii Jj Kk Ll
Mm Nn Oo Pp
Qq Rr Ss Tt
Uu Vv Ww
Xx Yy Zz 1 2
3 4 5 6 7 8 9

PICK-A-PATTERN guide

MAKE YOUR lettering unique! By varying the way you fill in your letters with color or pattern, you can make hundreds of different creative lettering alphabets from the ideas in this book. This section contains 75 patterns you can use for all kinds of occasions. It will also inspire you to come up with your own ideas!

If you're making a poster or greeting card, the lettering will be the center of attention, and any of the patterns here will work well for you.

If you're preparing lettering for a scrapbook page, you'll want to consider the best pattern for the overall effect your page will create. How to decide which pattern is right for a page? Here are some pointers.

1 What are the moods, themes, and color schemes of your photographs? The only way to enhance your pictures with creative lettering is to make sure the letters' colors match the themes and colors of the pictures. So don't rush: spend a moment enjoying your photos. What colors do you see? Are there patterns—on people's clothing, or in the backgrounds—that are strong features of any of the pictures? Is the overall mood loud and joyous, or something a little quieter?

2 With the photos in mind, flip back and forth from page to page, using this section as a reference. Which colors match the colors in your photos? Which patterns do? Select a few that are good matches. If your pictures are of a birthday party for a preschooler, the balloon pattern will naturally be one of your choices.

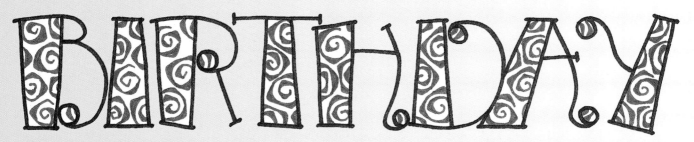

3 Look at the alphabet you've selected. How much blank space is available for a pattern? Can a big pattern fit? If your letters are narrow, you're better off with pin stripes or a simple dot pattern. But if there's lots of room, as there is in Chunky Block, go ahead and pick that mountain pattern!

51

52

53

54

55

56

57

58

59

60

61

62

63

64

65

66

67

68

69

70

71

72

73

74

75

Lettering Toolbox

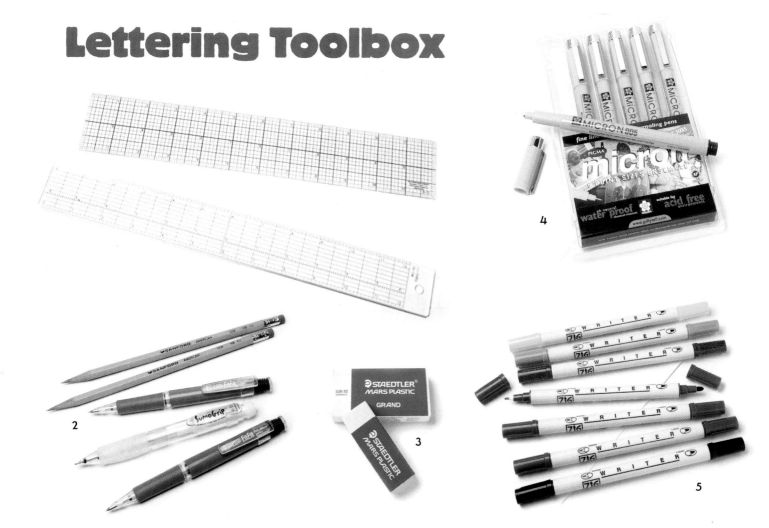

Ruler: (1) A good ruler is necessary for drawing guidelines for your lettering. It will help you keep your letters even in height and appropriately leveled on your paper. C-Thru Ruler Company is known for their quality rulers. It helps to be able to see the paper, so try to get a transparent ruler.

Pencil: (2) You can't do great lettering without a pencil! A regular pencil with #2 lead is just fine, while a mechanical pencil helps in making the finest lines. Sakura makes great mechanical pencils. Remember: Always do your letters in pencil before making them permanent with a pen. And be sure not to press hard with your pencil: this will make erasing much easier!

Eraser: (3) A good-quality eraser is essential. Staedtler is known for their quality. If you want an enormous eraser to cover large areas, there is one by Cut-it-Up (it's called "Erase-it-Up").

Fine point pens: (4) Fine-point pens are necessary for detail. The medium tips are perfect for journaling and outlining smaller lettering. For standard-sized lettering, opt for the 05 or 08 size (the largest tips). Several companies sell these pens both in sets and individually. Try the Micron pens by Sakura. EK Success makes the ZIG Millennium pens and Marvy Uchida makes the Medallion pens. All are good options, available in a small range of colors.

Dual-tip pens: (5) This type of pen provides a thick and thin point in the same colored ink in one pen. The ZIG Writers by EK Success are available in 48 colors and the Marvy Artists by Marvy Uchida come in 24 colors. When purchasing pens for scrapbooking and other projects that you want to preserve, it's important to look for the following qualities: Pigment ink, acid-free, archival quality, lightfast, waterproof, fade proof, and non-bleeding.